CONWY & DISTRICT PUBS

PETER JOHNSON & CATHERINE JEFFERIS

AMBERLEY

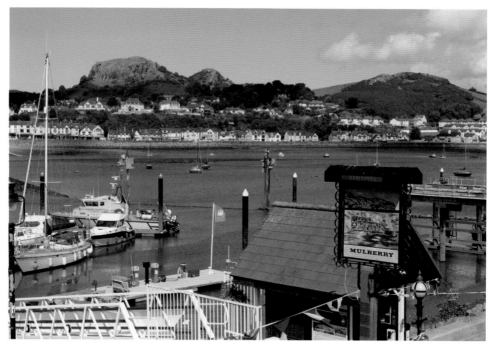

River Conwy from the terrace of the Mulberry, Conwy Marina.

In memory of Don Hughes, a connoisseur of fine ales and good pubs.

First published 2016

Amberley Publishing
The Hill, Stroud
Gloucestershire, GL5 4EP

www.amberley-books.com

Copyright © Peter Johnson & Catherine Jefferis, 2016
Maps contain Ornance Survey data.
Crown Copyright and database right, 2015

The right of Peter Johnson & Catherine Jefferis
to be identified as the Authors of this work has
been asserted in accordance with the Copyrights,
Designs and Patents Act 1988.

ISBN 978 1 4456 5312 9 (print)
ISBN 978 1 4456 5313 6 (ebook)

British Library Cataloguing in Publication Data.
A catalogue record for this book is available from
the British Library.

Typesetting by Amberley Publishing.
Printed in the UK.

Contents

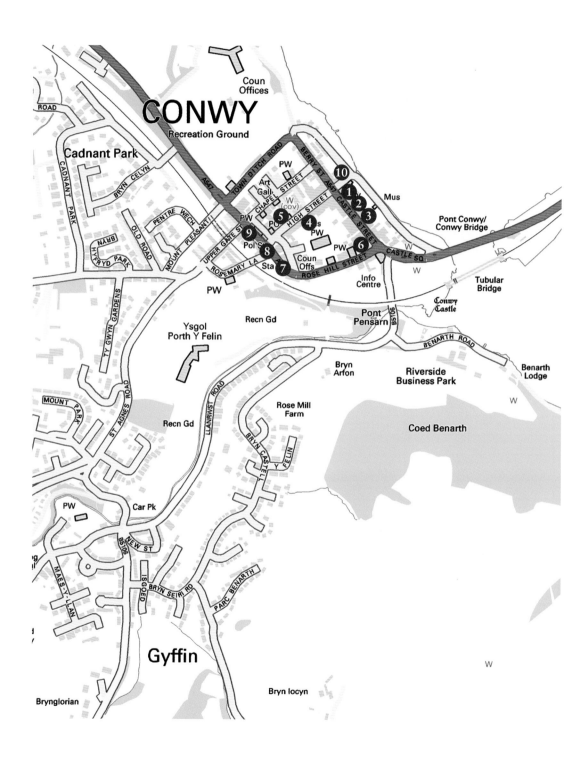

Introduction

Researching the history of the inns and pubs of our area has been a fascinating task, not least because of the diversity of the topography and the corresponding variety of hostelries. We have encountered traditional country pubs with links to medieval churches; inns along ancient drovers' paths, coaching routes and turnpike roads; former grand houses belonging to the landed gentry; seaside locals; Victorian gin palaces; and pubs built in more recent times to cater for a specific clientele. It soon became clear to us as we travelled through this spectacularly lovely part of North Wales that each pub, as well as having its own unique history, also plays a part in the history and development of what has become a very popular tourist area. This, then, became our aim: to illuminate the history of Conwy and its surrounding towns and villages through its pubs and inns.

The snappily named Conwy County Borough has a population of around 116,000 and at 1,130 square kilometres is slightly larger than Hong Kong. As well as numerous small hamlets and villages it includes larger towns such as Llandudno, Colwyn Bay and of course Conwy itself. This made for an interesting dilemma – which pubs to include, and which to leave out? Pressing on with the research, we discovered that some pubs had much original source material while others, sometimes inexplicably, had very little. As well, much has already been written about certain establishments and is readily available elsewhere. We therefore set ourselves the task of bringing new information and themes into our pub mini-essays. A third, self-imposed consideration was that each hostelry should be no more than roughly twenty minutes' drive from Conwy town (notwithstanding traffic conditions on the A55). And so we compiled our list; if your own favourite watering-hole has been left off, we do apologise.

As we were writing this book, a recurring yet unintentional theme was travel. Whether you are local to the area or a visitor, we hope you find something of interest within these pages and maybe even feel moved to travel yourself to visit some of the pubs – perhaps viewing them through different eyes.

Peter Johnson & Catherine Jefferis, 5 September 2015

Conwy Town

1. Former Black Lion, Castle Street

Archaeological evidence taken from an original roof timber of the Black Lion dates the felling of the tree from which it was taken to the winter of 1441–42, suggesting that the building was erected sometime later in the fifteenth century. This makes it the second oldest of two medieval buildings remaining in the town, the first being nearby Aberconwy House (1417–20). However, in May 2013 workmen for Dwr Cymru Welsh Water uncovered evidence in Castle Street for a building probably dating back to the time when the castle was built in the thirteenth century.

The fifteenth-century building was probably a two-bay hall house with jointed crucks (curved timbers which support the roof of a building). Around 1589 the building was modified to a storeyed house and had a main chimney inserted. The date above the door, 1589, and the letters J B E are believed to relate to John Brickdall, vicar of Conwy, and his wife: a commemoration of the rebuilding of the house, the tenth anniversary of his marriage to Em Motley, and the birth of his third son. Later additions were the bays and dormer to the front of the house.

Further alterations took place when the building was converted to an inn. In the *Whitehall Evening Post* of 5–7 June 1760 William and Jonat Evans informed the public that they had kept the Black Lion in Conwy from 1746 to 1749, showing that it was actively an inn at this time – and possibly before then. They moved in 1749 to the King's Head in Conwy, leaving there at Michaelmas 1758, and had 'enter'd since All Saints last into a new and commodious Inn, call'd the Bull's Head'. The report goes on to give a glimpse of Conwy in 1760; it tells the reader that the Bull's Head 'is now well air'd, and furnish'd with good beddings and other necessaries, fit for the reception of gentlemen, passengers and others,' and that 'there is a good Stable that will contain thirty horses and upwards, and proper Stalls for Gentlemen's Hunters'. They left the Bull's Head sometime before 1778; in that year the widow of landlord William Oakes married Samuel Read, who took over the running of the inn.

Towards the middle of the nineteenth century the landlord of the Black Lion was Edward Williams. He had a particular interest in turnips and entered year after year in the Conwy Agricultural Show, sometimes winning, but also sometimes not, such as in

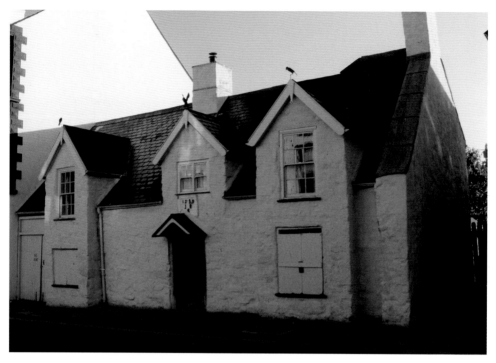

The Black Lion.

1849 when his crop was not well drilled. He had two acres of land which he devoted to this activity. During this period markets were held at the Black Lion for wheat, barley, oats and beans, and it was the venue for public auctions of property within the district. An outbuilding at the back of the inn was also a local centre for pig-dealing, a function it continued to the end of the century.

By 1897, inns and pubs in Conwy were attracting the attention of big players. On 30 July that year the Black Lion, with fellow Conwy establishments the Albion and the Erskine Arms, were subject to a draft conveyance (in consideration of £5,350) to Ind Coope & Co. Ltd. The brewery firm held on to the Black Lion until 1935, when they rebuilt the Blue Bell next door. To further stimulate trade in their new location they prohibited the sale of alcohol in the Black Lion, a clause which was to remain for all subsequent owners.

As is to be expected for a residential and working building of nearly 600 years, the structure we see today has been subjected to a number of alterations, additions and demolitions since its first manifestation; at the present time (August 2015) the Black Lion is under renovation by a private owner.

2.Blue Bell (Gloch Las), Castle Street

With so many watering holes in Conwy in the nineteenth century, we can only guess what competition there could have been between them. In the 1840s vegetables were certainly an issue; the landlord of the Blue Bell, Edward Jones, exhibited his turnips at

the same shows as Edward Williams of the Black Lion. Unfortunately Edward Jones' success in this field was equally limited: though his turnips grown on a one-and-a-half -acre plot were good, in 1847 they were too small and in 1849 they were not properly drilled. It would be of interest to know where these turnip plots were; might they have been within the walls of the town? In 1850 Samuel Lewis wrote in his *Topographical Dictionary of Wales* that 'the area within the walls is occupied with garden-ground, and the houses are comparatively few and in detached situations'.

Competition of a different sort was prominent in the early years of the twentieth century. John Crewe Smallwood was landlord of the Blue Bell in the 1890s, leaving the pub in 1897 only to return to it in 1904 for a year. During this time his son Percy was making a name for himself as an athlete. This forgotten Welsh wonder started his career locally, which included winning the quarter- and half-mile championships at Llanrug in August 1904, and in September first prize at the Bontnewyyd sports. By January 1905, aged nineteen, he was winning race after race with the Oxford Club, one of the richest athletic institutions in Brooklyn, USA. In a letter home he says, 'I am still doing great things here on the running path. I have won fourteen prizes up to now, eleven firsts, two seconds, one third. Most of the prizes were gold medals and silver cups. I have also won three championships.' Being a professional runner he could not compete in the 1908 London Olympics, though he regularly ran against members of the USA team in their training for the games – roundly beating all of them. When he was thirty-eight, Percy 'Doc' Smallwood was still competing and held the world professional records for 5, 10, 12 and 15 miles.

Two other firsts are associated with the Blue Bell and Mr Smallwood. September 1895 saw the first arrival of ale in Conwy from Burton-on-Trent via the Manchester Ship Canal. This consisted of twenty casks landed at the quay and consigned by Messrs Worthington to their Conwy agent, Mr J. C. Smallwood. The second occurred on Wednesday afternoon, 29 January 1896, when a representative of the *Weekly News* was present at the new Telephone Call Office and Exchange at the Blue Bell when communication was first established (via Llandudno) with the Chester office of the National Telephone Company. This new device was installed later that week in twelve local homes and offices.

The Blue Bell was the venue for the annually-held Court Baron and Court Leet. In their original feudal form the Court Baron was generally held every three weeks, with the Court Leet every six months. They dealt with issues such as transfer of land, payment of services due to the lord, petty law and order, and the administration of communal agriculture. By the nineteenth century many of these responsibilities had been taken over by other agencies. The most pressing, indeed only, concern at the dinner of 29 October 1897 was vandalism of Conwy's town walls; after this discussion toasting and singing prevailed. In 1892 the *Carnarvon and Denbigh Herald* suggested that the courts had been held at the Blue Bell for over 200 years; however, in 1894 the *Weekly News* reported that it had been 120 years.

In 1935 the Blue Bell was rebuilt by Ind Coope & Co. Ltd. On certain evenings of the week singing still prevails with live music in the pub, all under the gaze of fascinating pictures and posters from a rather different age, when Janis Joplin and Jimi Hendrix were at their peak.

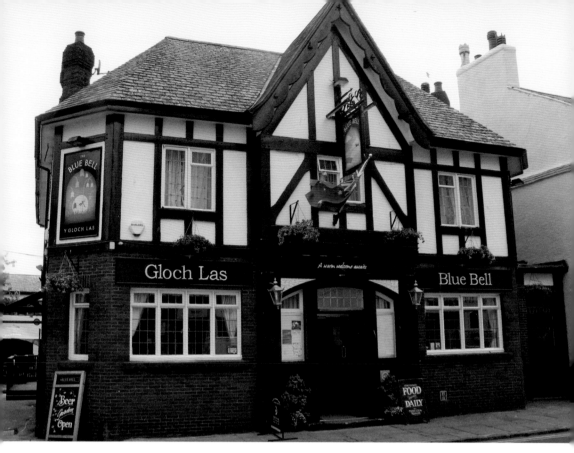

Above: The Blue Bell.

Below: Heron behind the bar of the Blue Bell.

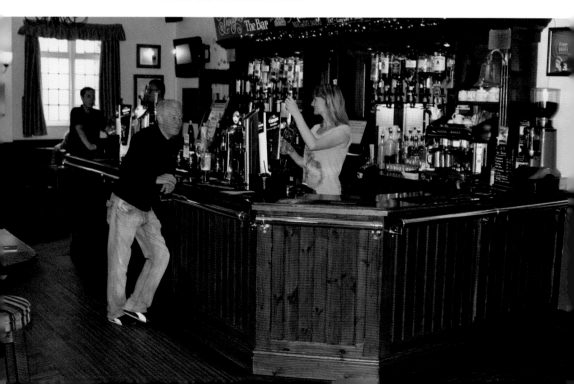

3. George & Dragon, Castle Street

Conwy's Castle Street was evidently a good thoroughfare for hostelries. Over the years there have been at least eight taverns and public houses on this road alone; this number does not include the more informal alehouses that in earlier times tended to be based around the point of brewing (often a private house), and were not likely to adopt an official name in the same manner as the inns and taverns.

Today, only two pubs remain on Castle Street: the Blue Bell and its next-door neighbour, the George & Dragon. According to the 1889 Ordnance Survey, the latter was formerly two separate but conjoined premises, and the current pub is separated by a central passageway with the bar on the left and the licensed restaurant on the right.

Conwy inns appear to have had a bad outbreak of counterfeit coins in 1882: in April, two hawkers from Wrexham were remanded in custody 'pending further instructions from the Mint authorities' for having offered a counterfeit coin at both the Mail Coach and the Erskine Arms, and just a month later one John Felburn, who hailed from County Sligo, was charged with 'uttering a bad half-sovereign' at the George & Dragon. However, the prosecution later withdrew this charge.

An unusual article appeared in the *Welsh Coast Pioneer* in 1902 concerning the landlord of the George & Dragon, Mr Kemp, whose pet monkey had become attached to a kitten and would take it to bed in its arms every night. Even after the kitten had become fully grown, says the article, their 'dumb marks of friendship are the cause of endless amusement to Mr Kemp's customers'. What is perhaps most surprising about this story is the fact that Mr Kemp having a pet monkey in the first place did not appear to arouse particular comment.

The George & Dragon, on the right, around 1900.

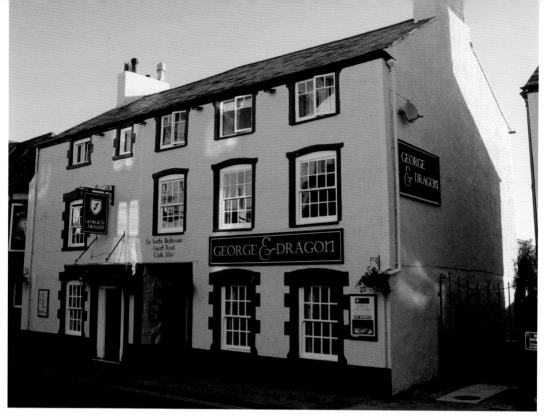

Above: The George & Dragon today.

Below: Bar of the George & Dragon.

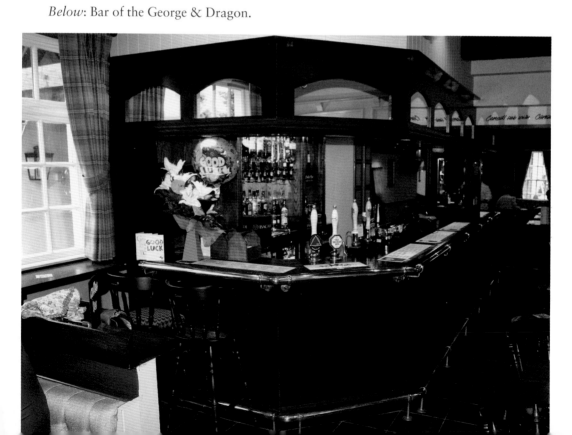

For several years from the late 1800s the George & Dragon was owned by Thomas Salt & Co., brewers in Burton-on-Trent, in whose charge the inn evidently went through a period of improvements and renovations. In July 1915 there was a planning application for a new entrance doorway, followed by one for an enlargement to the smoke room. Exactly one hundred years later the pub was reopened by its parent company Punch Taverns after extensive renovations costing £315,000, after a two-month closure. Its opening night was preceded by a special event for local dignitaries, including the area's MP.

4. Castle Hotel, High Street

The Cistercian Abbey of Aberconwy was founded on 24 July 1186 by monks from Strata Florida, Ceredigion, having originally settled south of Caernarfon. By 1192 the monks had resettled near the mouth of the River Conwy. The church of St Mary and All Saints was the abbey church; while no part of the existing structure is older than the twelfth century, it is possible that the churchyard may date from the eighth. The abbey and church received the patronage of Prince Llywelyn the Great, who became a monk shortly before his death. Llywelyn's body was interred in the church, though his coffin is now in Llanrwst parish church. The abbey and church was sacked and looted in 1245 by Henry III's men, but it remained a major religious centre until 1277 when Llywelyn ap Gruffydd signed the Treaty of Aberconwy and capitulated to Edward I. Some six years later the monks were relocated by Edward to Maenan. The wall that divides the churchyard from the Castle Hotel car park dates from this period and is believed to have belonged to the abbey.

Today's hotel was formerly two buildings: the King's Head (originally a farmer's house), and a medieval guesthouse which later developed into the Castle. It has been suggested that a cockpit used to be in the garden of the King's Head where gypsies used to settle their quarrels. Across the road behind Plas Mawr lie the remains of another cockpit, probably nineteenth century in origin. Behind the modern façade of the former King's Head remain timbers dating from around 1500, although the stables behind the Castle house the earliest surviving part of the site, some of its masonry may have been from the monastery.

Both the Castle and the King's Head were coaching inns, as were their contemporaries within the town walls. They were also venues for property sales. One held at the King's Head in 1744 was for several properties on the Llŷn peninsula. A coaching advertisement in 1776 gives some details of how this side of the business was conducted. Thomas Carter, based at the Yacht Inn, Chester, begged to inform and give thanks to 'Nobility, Gentry, etc', who had encouraged his plan 'of rendering the travelling through Wales to Holyhead more liberal and unconfined'. One of the coach stops was the King's Head, Conwy. Each passenger was charged the rather large sum of £1 11s 6d (£1.58), with luggage at 2d per pound. It seems that a superior form of travel did not come cheap, nor was it likely to be comfortable. In 1835 things may have improved for The Tourist, a light post coach, on its daily run between the Castle and the Uxbridge Arms Hotel, Caernarvon, could take the scenic route around Snowdon via Llanberis and still do the journey in just eight hours.

The King's Head cannot be found in newspaper reports and advertisements after 1776; the Castle Hotel appears in the press from the 1830s. There is one rather confusing report from 1884 concerning licensing disagreements that begins by referring to an inn as the King's Head, but later in the report calls it the King's Arms.

By the 1830s, if not before, the Castle was considered to be the 5-star venue in town. They did not simply advertise for indoor servants: an 1847 advertisement for a footman requires 'an active and steady man, who thoroughly understands [silver] plate cleaning, and waiting at table, also to valet a gentleman.' Such staff would have been necessary for the public dinner – a guinea (£1.05) a ticket, to include wine – given by Robert Stephenson on 17 May 1848 'to celebrate the triumphant completion' of the Conway Tube, the tubular railway bridge crossing the River Conwy. The hotel developed not just a certain type of clientele but appropriate services, such as the ministrations of surgeon-dentist J. Brophy, who intended to visit the hotel on 11 and 12 September 1843.

Applications for Acts which would allow the enclosure of land became a feature of the 1840s – witness, for example, the development of Llandudno at the end of the decade. The centre for this activity was the Castle Hotel, where from 1844 onwards meetings were held by the Commissioner to discuss and object to applications. Around the same time road improvements were proposed and debated in the Castle, such as the one planned in 1846 to run from Llanrwst to Ffestiniog. Agricultural improvement was also gaining support. In 1845 Mr S. Owen of the Castle Hotel was elected to the Committee of the Society for Promoting and Encouraging the Best System of Agriculture.

The hotel upheld the traditions and values of earlier times during the remainder of the nineteenth century and through the twentieth. Although, the coaching aspect faded as the railways arrived and in the 1880s the outside was completely rebuilt in the Jacobean style. In 1931 the Castle passed into the ownership of London-based hotel company Trust House, which eventually became Trust House Forte. In 1994 Regal Hotels took over; in 2000 the hotel was back in private hands under its present owners, the Lavin family.

From medieval times onwards the Castle Hotel has catered for an eclectic mix of customers, from cock-fighting spectators in the early years, through the coaching era and into its role hosting select gatherings. Where formerly famous names such as Charlotte Brontë, Samuel Johnson and William Wordsworth stayed at the hotel, in recent times it has welcomed celebrities including Terry Wogan, Jules Holland, Florence and the Machine and the crew and presenters of Salvage Hunters, thus maintaining traditions while keeping up with the times.

5. Ye Olde Mail Coach, High Street

Contrary to popular thinking, the word 'ye' as a definite article is pronounced 'the' (but not in phrases such as O Come, All Ye Faithful when the word has a different function). It stems from Anglo-Saxon written English when a letter called 'thorn' – written similar to the modern 'y' – was used to represent the 'th' sound. Thus 'Ye Olde Mail Coach' should be pronounced 'the old mail coach' (the final 'e' in 'olde' being silent).

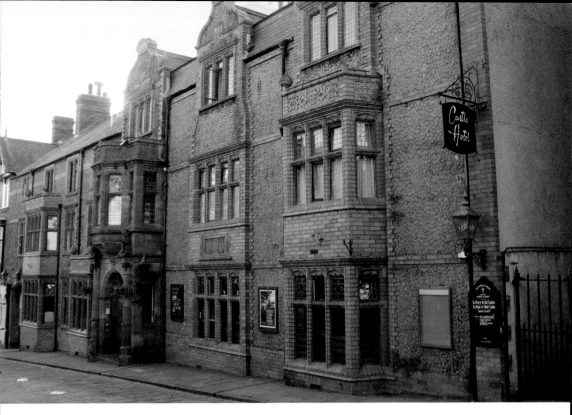

Above: The Castle Hotel.

Below: The bar of the Castle Hotel.

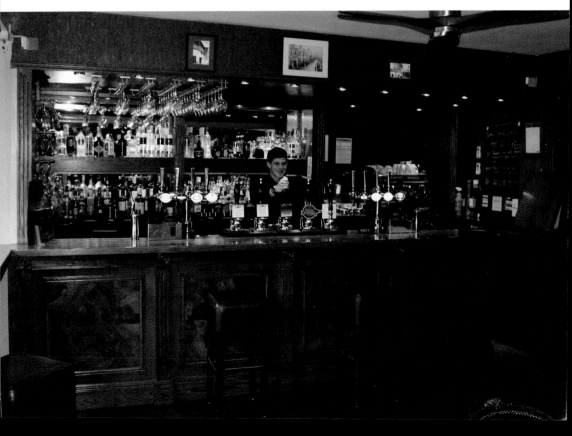

The pub stands approximately on the site of the former Coach & Horses, one of the older inns in Conwy, although the current building dates back only to the early twentieth century, appearing on the 1913 Ordnance Survey map. Its name is clearly linked with the previous hostelry, both dating back to the eighteenth century when coachmen would stop there to change horses, or simply for a break before continuing with their journey. The access for the horse-drawn coaches was to the side of the inn and into the yard behind it, part of which is now a beer garden; holes for the horses' tethering posts can still be seen in one of the side walls, and the remnants of the old forge where the blacksmith would be kept busy are still in outbuildings which were probably originally stables.

Both the interior and exterior of the pub have changed in more recent times. The current open bar area was originally three small rooms, with stairs in the centre of the building leading upstairs where there were once five letting bedrooms. During the course of renovation in the 1990s planning application was sought to block up the two front entrances in favour of one central doorway. The application was turned down as it was felt this would not be in keeping with the original appearance of the building. However, one of the workmen discovered an old photograph showing the pub with only one doorway – in the centre of the building. Planning permission was subsequently granted.

The Mail Coach closed down twice during 2010–11, but opened again in April 2011 after an extensive refurbishment and has proved a popular eating and drinking spot for both locals and tourists. It was granted Grade II-listed building status in 2005 because of its special architectural interest as an 'early twentieth-century public house retaining original character and detail'.

6. Bridge Inn, Rose Hill Street

Given its prime position on the main road into Conwy from across the river, and almost within touching distance (with very long arms) of the castle, it is no surprise that this establishment was originally called the Castle View Hotel. It was probably built in the mid-nineteenth century; the hotelier in the 1871 census was one William Abram, under whose tenancy it became a temperance hotel, and between 1880–96 it was run by his son Thomas. In April 1904 it was reported in the local press that William's other son, Samuel, had died in New York where he had imigrated in 1899 having worked as a solicitor in Conwy for many years. The article refers to the Castle View Hotel 'now called the Bridge'. The licence was transferred in 1897 from Thomas Abram to Miss Mary Davies.

As well as Conwy castle, the inn also commands a fine view of the suspension bridge spanning the river. Built by Thomas Telford and completed in 1826, it was one of the first suspension bridges in the world and replaced the ferry which was situated at the same spot. The hotel's new name was ostensibly because of the outlook onto the by-now famous landmark, but possibly because of a family connection with a Mr Bridges, a shopkeeper whose business operated across the road from the hotel. It is possible it was called Bridges' Hotel before becoming The Bridge. Its Welsh name (used locally as frequently as its English) is Y Bont.

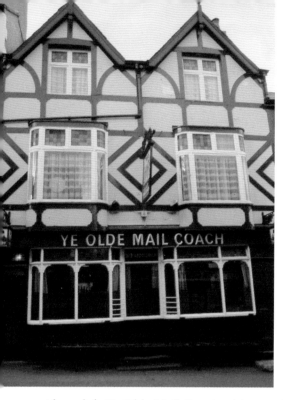
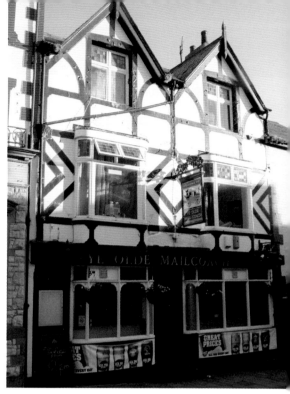

Above left: Ye Olde Mail Coach with two side doors.

Above right: Ye Olde Mail Coach returned to a central door.

Below: Tracey behind the bar of Ye Olde Mail Coach.

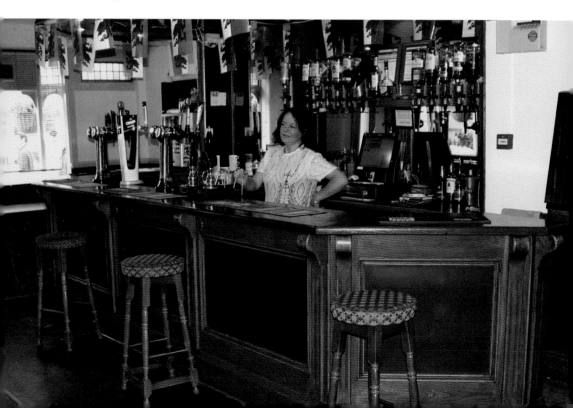

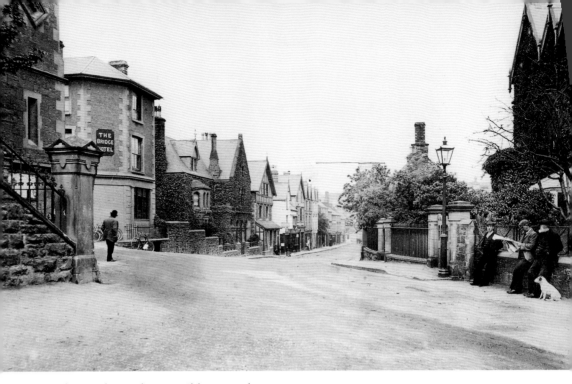

Above: The Bridge, possibly around 1905.

Below: The Bridge / Y Bont today.

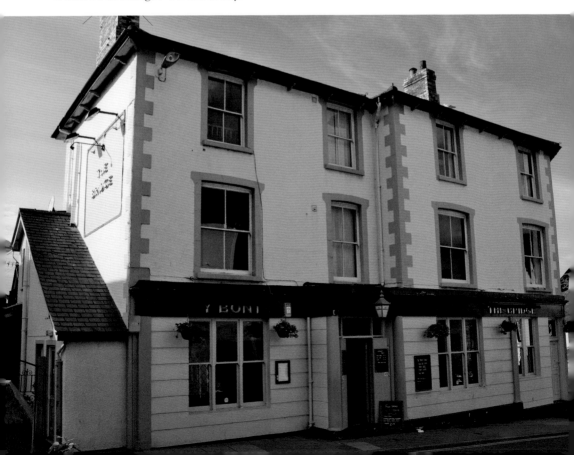

In 1928 Building Control plans were approved for alterations to the hotel by Ind Coope Ltd. It was subsequently taken over by Marston's until it was announced in early 2015 that The Bridge had been acquired by four local breweries: Purple Moose Brewery, of Porthmadog; Bragdy Conwy Brewery, based in Morfa Conwy; Bragdy'r Nant, of Llanrwst; and Great Orme Brewery, of Glan Conwy. This consortium had taken over the Albion in Conwy in 2012, when it was believed to be the first time in the UK that four rival breweries had joined forces to run a pub together. The Bridge opened under the new ownership in April 2015, offering traditional pub food and catering largely for families.

7. The Malt Loaf, Rosehill Street

The Malt Loaf dates from the late eighteenth and nineteenth centuries; an early visitor was Charlotte Brontë who stayed in the hotel while on her way to Ireland in June 1854. Until it became the Malt Loaf in 1996 it was known as the Erskine Arms Hotel, after a family of major local landowners. In September 1865 Lady Erskine sold her estates in one of the greatest sales of landed property which had occurred in North Wales. Thousands of acres of farms and parkland were sold, along with various mines and, perhaps poignantly, the great houses of Pwllycrochan and Bodlondeb themselves. Plots of land and buildings in Conwy town were included, together with the White Horse and gardens, Boot Inn and shop, the Crown Inn, Conwy Castle Inn, Old Liverpool Arms, and the Market Hall; but not the Erskine Arms Hotel, which was the venue for the sale. This went on the market in 1871; the entire property consisted of the hotel, a refreshment room (adjoining the railway station), five cottages close by, large stables, and a fine billiard room detached from the hotel at the back of it. Unfortunately for the seller the highest bid was below the reserve price, and ten years later a local merchant bought the Erskine Arms Hotel and a number of nearby houses for £2,050. In 1897 Ind Coope & Co. Ltd spent £5,350 for the hotel, the Black Lion and the Albion Vaults as a job lot. They proceeded to enlarge the hotel, update the billiard room and revamp the toilets, among other alterations.

The generosity of Lady Erskine was often remarked upon in the local press. When the cold winter of 1864 struck she gave a gift of coal to those too poor to buy their own. In the 1865 sale she made a present of a house and yard to an elderly tenant. But she was not the only socially minded associate of the Erskine Arms: in 1895 landlord R. Roberts was a Poor Law guardian for the parish.

In August 1862 the eminent violinist and vocalist Mr M. Jacobowitch and his party entertained a 'fashionable audience, comprising the elite of the town and neighbourhood' in the hotel's assembly room. However, it was not always refined elegance; the hotel was once challenged to fisticuffs. Sometime late on Sunday 27 March 1910 a drunken chap was caught cajoling the statue of Prince Llewelyn to come down from his plinth in the square to have a fight, whereupon the potential pugilist was spotted by the police and moved on. Undeterred, the combatant offered to fight the hotel and then the toll bridge (we might guess that both silently refused). To save further bother he was locked up for his own safety, but liberated later in the evening.

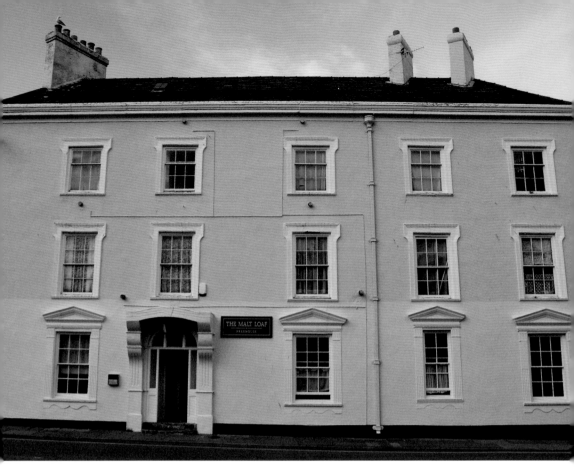

Above: The Malt Loaf.

Below: The bar of the Malt Loaf.

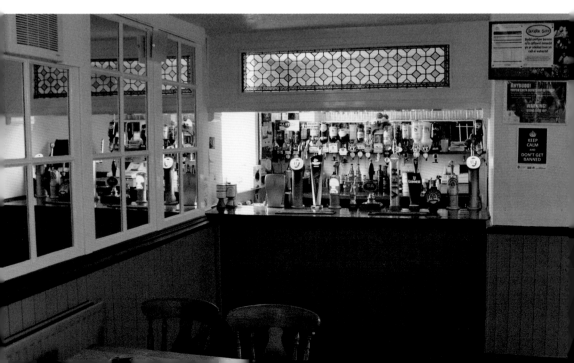

The Erskine Arms Hotel was home to the Conway Horse Show Society, which held its committee meetings and dinners there; the accompanying horse sales were run by Messrs Blackwall, Hayes & Co. It was also the centre for football in the region, being the location for the North Wales Coast Football Association from the end of the nineteenth century. Thus the Malt Loaf has been, and continues to be, a venue for many and varied activities in the town. However, it may soon be known by its original name as its owner, Stange & Co. Ltd., has at the time of writing submitted a planning application to refurbish the pub and call it once again The Erskine Arms.

8. Bank of Conwy, Lancaster Square

Situated on the corner of Lancaster Square, this handsome former bank in the neo-classical style is in marked contrast to the much older buildings that surround it. It is described by the British Listed Buildings organisation as being constructed 'inter-war' in the style 'characteristic of the period'. One source claims that it was bought by the Midland Bank in 1913; apart from the obvious disparity with dates, this raises the question of whom the Midland bought it from. A possibility might be the North and South Wales Bank, who were taken over by the Midland; however, this merger was completed by 1906. The building became a branch of HSBC when it took over Midland Bank in 1992 and later phased out the Midland name in favour of its own.

In November 2013, HSBC announced the proposed closure of its Conwy branch, blaming the rise of internet banking and a corresponding change of personal banking habits for a significant fall in the number of customer visits. The announcement caused a good deal of local consternation; not only was it the only remaining bank in the town, but also one of only two cashpoints. Despite intervention by the local MP, who suggested that closing local banking services in a major tourist destination was a mistake, the branch was nonetheless closed in February 2014 and the building put up for sale.

It was taken over by the owners of a local wine and craft beer shop who gave it an extensive refit and a new name – the Bank of Conwy – and opened it as a wine and tapas bar in June 2015. It is now possible to have the unusual experience of eating and drinking in the former banking hall under the lofty corniced ceiling, or even downstairs in the vaults. Perhaps fittingly, the bank's wine stock is stored behind bars where once the denizens of Conwy's valuables were kept in safe deposit boxes; even the hefty multiple-lock steel doors still remain.

9. The Albion, Uppergate Street

As its address would suggest, the Albion is situated on the road leading out of Conwy via the Upper Gate, originally one of only three entrances to the town. There were once two pubs on this corner site, the then Albion Vaults and the White Horse, which amalgamated during the mid-1920s.

In January 1872, an anonymous correspondent wrote to the *North Wales Chronicle* in response to a previous article criticising Conwy's drainage system. The letter-writer states his wish to correct the statement 'which was quite contrary to facts, and [...] made in entire ignorance of them', pointing out that the principal drain which started by the corner of the Albion Vaults was around four feet deep, made its underground way

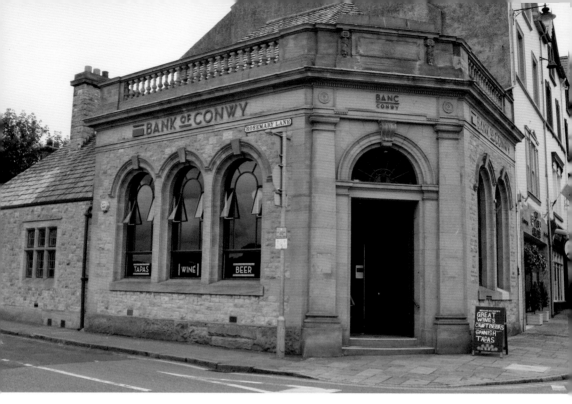

Above: The Bank of Conwy.

Below: The bar of the Bank of Conwy.

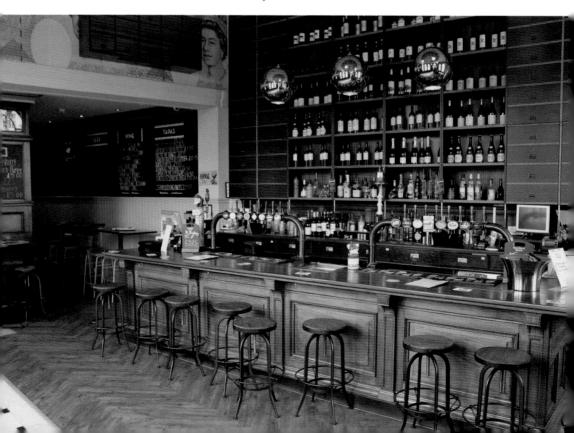

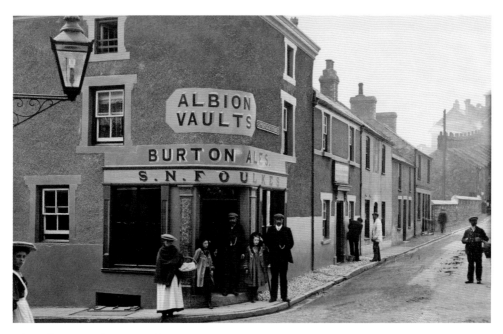

The Albion Vaults, around 1915.

through the town to the sea, and was sufficient to drain 'several of the cellars'. He goes on to stoutly defend the town's drain collection, cataloguing it with such geographical precision that the reader is left idly wondering whether this correspondent was in fact the man responsible for Conwy's drains.

Another newspaper article from the *Chronicle*, this time in September 1916, concerns the matter of the landlord of the Albion Vaults, one R. O. Williams, who had applied to the Caernarfonshire Tribunals for conditional exemption from conscription on account of his age and the fact that in his capacity as a farmer – a common secondary occupation for pub landlords in this area – he owned 300 sheep, as well as cattle. His solicitor, with some pride, stated that Mr Williams was a man 'of considerable weight and substance', qualities he felt would detract from his military value. The tribunal chairman rather wittily enquired whether army service might not reduce his weight. After a few weeks Mr Williams appeared again before the tribunal, this time with a medical certificate declaring him 'totally unfit for any military service'. He declined the chairman's suggestion that he join the special constables instead, stating that he was 'too busy'. He must indeed have been busy; three years later he was up before Conwy magistrates for selling two bottles of stout for more than the legal price, for which crime he was fined £15.

The current Albion dates largely from the 1920s, the period when the combined two pubs were rebuilt in the fashion of the day. Although the façade has been more recently replaced, the interior is something of an architectural time capsule; it was untouched by the trends through the decades for pulling out original features and knocking small rooms through to create large bar areas. The lobby still has its original art nouveau tiling, the lounge has its original art deco baronial-style fireplace; the bar has retained its counter, mirrored bar-back and four of the old hand-pulls. The serving hatch from

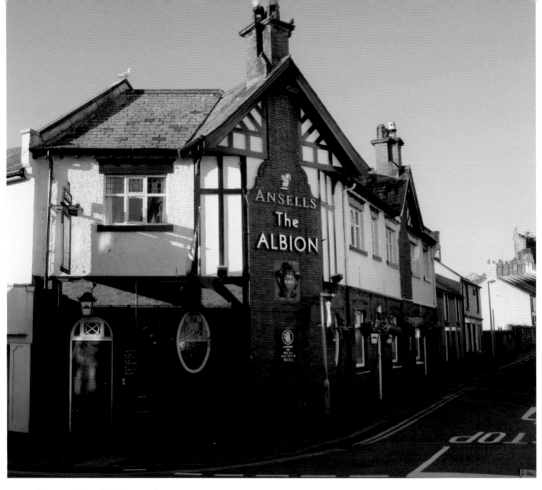

Above: The Albion today.

Below: Pulling a pint in the 1920s bar of the Albion.

the bar to the snug – formerly the smoke room, according to the etching on the door pane – is still in place, as are some of the old push bells above the fixed seating which were used to summon bartenders.

Following waning fortunes and several changes of licensee, the Albion closed down in 2010. It was bought at auction the following year by a London businessman who invited local breweries to take it over. A consortium of four breweries rose to the challenge, restored its original 1920s features and reopened it in February 2012, going on to take over Conwy's Bridge Inn in 2015. The Albion is Grade II listed, and won a CAMRA Pub Design Award in 2013 for its 'historic interior of national importance'.

10. Liverpool Arms, Lower Gate Street

The Liverpool Arms is the earliest surviving building on Conwy's quayside, dating back to when the town was a flourishing port. The quay itself was built in the 1830s and was used to export slate and other cargos. It was also used for fishermen; before the quay, boats were simply pulled up to the shoreline. The inn pre-dates the quay by a hundred years or more. This can be seen from the typically eighteenth-century low proportions of the ground and first floors. Built against the medieval town walls, it is situated close to the Lower Gate (or Porth Isaf), one of the three original entrances to the fortified town.

The inn's name may have come from its landlord between 1828 and 1851, John Jones, a ship's captain who sailed between Conwy and Liverpool. His last job was as stationmaster of the new Colwyn railway station. He died in 1865 and is buried in St Mary's churchyard.

The inn's main entrance was originally from the High Street into what is now the rear of the pub, with the back entrance leading from the quay. At a licensed hearing in 1903, a time when it was illegal to be drunk in a pub, the police asked for one of the entrances to be blocked off to assist their job in monitoring the premises for intoxicated customers. Giving evidence, a local police sergeant stated that 'the better class of customers used one door, while the inferior class, such as fishermen and hawkers, used the other', also letting slip that the police would retire to the Liverpool Arms for luncheon after their monthly drill. It took another four years for the High Street door to be closed and a new one constructed at what became the front of the pub, obliging customers of all classes to use the same entrance.

After closing suddenly in June 2015 the pub's parent company, Enterprise Inns, appointed two new joint licensees from around fifty applicants, all keen to run what has been described as 'Conwy's most iconic pub'. After a swift £50,000 refurbishment, the Liverpool Arms opened its doors once again two months later in early August.

11. The Mulberry, Conwy Marina

The Mulberry lies around one kilometre north of Conwy. Opened in 1998, it is part of the Conwy Marina development; its attractive waterfront setting with stunning views across the estuary to Deganwy makes it a popular spot for boaty types and locals alike. Despite its relative newness, the Mulberry – or more properly, its location – does have an interesting history, which makes it worthy of inclusion in this book.

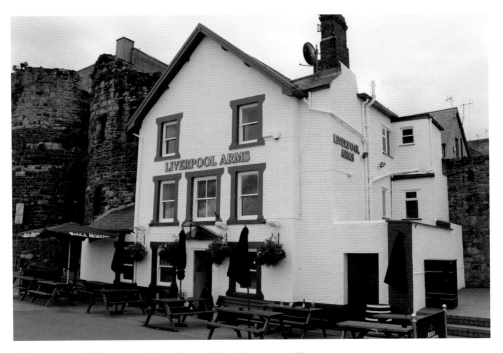

The Liverpool Arms, against the medieval town walls.

Historically, the main road along the North Wales coast ran through the ancient walled town of Conwy. While appropriate in the days of coaches and horses, modern traffic flow was turning the town into a notorious bottleneck, and in 1986 the UK's first immersed-tube tunnel was contracted to take the A55 Expressway underneath the River Conwy. A 300-by-200 metre basin was excavated at Morfa Conwy, where the estuary meets the sea. Six large sections of the tunnel tube were then cast. Each section was 118 metres long, 24 metres wide and 10.5 metres high, and weighed around 30,000 tons. The basin was then opened to the estuary and filled with water, and the tunnel sections were fitted with buoyancy aids, towed to their positions in the estuary and placed in a trench in the river bed. The Conwy Tunnel took five years to complete; it opened in October 2001. Conwy Marina was subsequently constructed at the water-filled casting basin. Opened in 1992, it provides 500 pontoon berths for leisure craft, making it the largest marina in Wales.

At the outbreak of the First World War, a military camp was situated on Morfa Conwy. A hand grenade, thought to be dating from this period, was found washed up on the beach after storms in 2007, necessitating a visit from army bomb disposal experts based in Chester to detonate it safely.

A plaque situated at the Morfa car park commemorates one of the best kept secrets of the Second World War. Between 1942 and 1944, Morfa Conwy once again became a military camp, this time for British and Dutch soldiers. In addition, hundreds of workmen began to descend on the beach area. Nobody knew why they were there, including the workmen themselves, and it was only until after the war that the mystery was solved.

Bangor-born civil engineer Hugh Iorys Hughes had foreseen that the Allied Forces' reoccupation would need harbours built from prefabricated components and floated to distant northern French beaches, because the established French ports were too heavily guarded. The workmen on the Morfa constructed three huge caissons – airtight chambers used in underwater construction – known as Hippos. Other components were made in other places and transported to Morfa Conwy for assembly. During 1943, as preparations for the Normandy landings increased, more than 200 Hippos were fabricated by thousands of men all around the country.

The completed structures were towed to France and linked together to create two harbour walls. They were utilised by the Allies to take ashore personnel, vehicles and other essential supplies which were crucial as the frontline forces advanced further into enemy territory. 'Mulberry' was the project's codename, and the artificial port became known as Mulberry Harbour. The pub and restaurant which today stands near the site of its testing is named after this secret wartime project, which played such a vital role in what is now known as the D-Day landings.

In 2010, Morfa-based Conwy Brewery announced the launch of three Heritage Ales, one of which was Mulberry Dark; described as 'a classic dark mild at 3.8 per cent volume', it was apparently a popular beer style between the wars.

The Mulberry hosted Conwy's first Real Ale Festival in March 2014.

All ship-shape in the bar of The Mulberry.

East of Conwy

12. Valentine Inn, Mill Road, Llanddulas

The village of Llanddulas, situated around four miles east of Colwyn Bay, has at its heart the Valentine Inn. It occupies the site of an old straw-covered cottage built of clay, referred to in a Llanddulas Terrier (the official documents regarding tithes) in 1791; the inn was however mentioned before this in a lease of 1788, thus making it the oldest in the village.

It is sometimes assumed that the pub is named after Llanddulas' most famous son Lewis Valentine, who was a Baptist minister and renowned political activist. His experiences during the First World War brought him to Welsh Nationalism and he became Plaid Cymru's first president and parliamentary candidate. However, as he was born in 1893, and as the Valentine Inn appears in written records more than a century earlier, this cannot be the case. Another theory regarding the pub's name is that it was first opened on Valentine's Day, which although pleasingly romantic cannot be substantiated.

In 1894 the Valentine's licensee, Joseph Jones, gave evidence to the Royal Commission of Land in Wales regarding the closing of what was known as the 'Parish Quarry', whose stone had been used for local road metalling for decades. A local landowner, R. W. Wynne, had summarily erected a padlocked gate to prevent access to the quarry. In his evidence, Joseph Jones spoke graphically of the hardships suffered by Wynne's tenant farmers at the hands of their tyrannical landlord, mentioning that many of them were unwilling to come before the Commission for fear of repercussions. At a time when the old feudal systems of exploitation by landowners of their workers were slowly beginning to change, Joseph Jones appears to have become of something of a folk hero for his outspokenness.

The late 1890s and early 1900s saw the Valentine – by now the Valentine Hotel – at the centre of the community. Part of the building was used as the village post office for some years; it was also used as the venue for formal celebrations of various kinds, including in October 1909 when the crew of the new Llanddulas lifeboat, the *Brother and Sister*, were entertained to dinner there following the naming ceremony by the Countess of Dundonald, of nearby Gwrych Castle. The lifeboat's coxswain appears to have had an aversion to public speaking: when called upon to respond to a toast he declined, answering instead by proxy.

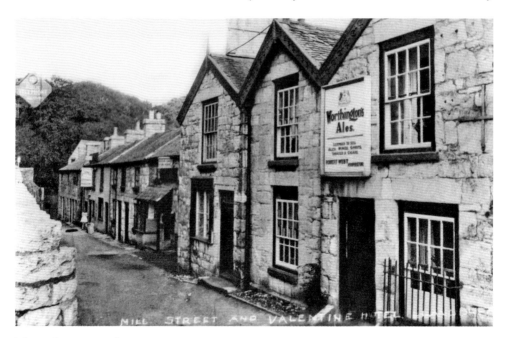

The Valentine, early 1900s.

From the mid-nineteenth century a back room at the Valentine was used as a rehearsal venue for many years by the Llanddulas Brass Band, later to become the Llanddulas Silver Prize Band. Judging by its many mentions in the local press, the band formed an important part of village life; it became famous throughout the region and was visited by many famous composers and conductors, including John Philip Sousa.

Llanddulas' semi-rural position did not prevent it being a casualty of the Second World War. On 20 December 1940 two parachute mines landed on the village, one in a field, causing some damage to property, and the other in the mill pond behind Mill Street. Although the pond fortunately took most of the impact, the consequence was more extensive. The church and rectory suffered broken windows and lifted roofs, and a large room at the rear of the Valentine, used as a Working Men's Club, was so seriously damaged that it was never replaced. The Valentine Hotel subsequently reverted to being the Valentine Inn.

The pub's interior today is still recognisable as the archetypal village inn it once was. The owners have resisted the modern lure of knocking small rooms through to make one large open space, and there are still several cosy rooms all linked by narrow corridors. Evening entertainments such as a poker club, darts and a Saturday sing-song night ensure that the Valentine remains at the hub of the local community.

13. Ship Inn, Abergele Road, Old Colwyn

No evidence exists that Queen Victoria visited Colwyn during her reign (1837–1901). However, there is potential evidence that she visited in 1832, aged thirteen, as Princess Victoria; in that year she began the diary that she continued to write for the rest of

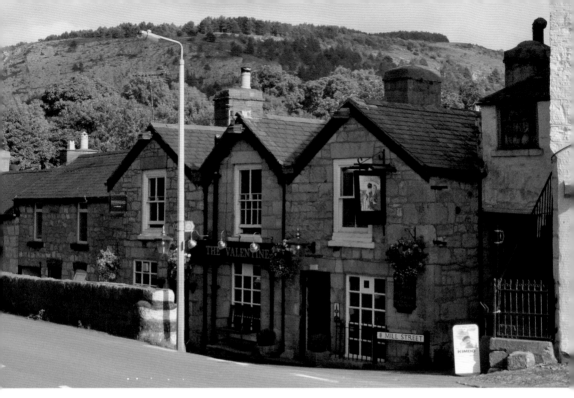

Above: The Valentine today.

Below: Luke behind the bar at the Valentine.

her life. On 15 October 1832, after visiting the Marquess of Anglesey (Henry William Paget, who famously lost a leg during the Battle of Waterloo) she was en route to Chester, along with her mother the Duchess of Kent and accompanying party. At 10.15 a.m., having ridden through grand and magnificent scenery, they changed horses at Conwy. At 10.55 a.m. they stopped to have the horses watered, having just ascended a very high hill from where she saw a beautiful blue sea, with two little vessels as distant white specks. They changed horses again at 11.40 a.m. at Abergele. Unfortunately Princess Victoria did not name where they watered the horses at 10.55 a.m., though her description, especially the times from Conwy and to Abergele, strongly suggests that it would have been Old Colwyn. Reference to contemporary maps of the main road across North Wales reinforces this suggestion. Local knowledge has it that the brief respite from the journey was taken at the Ship Inn.

Although perhaps not quite reaching this level of aristocratic connection again, the Ship Inn hosted the party to honour the return of local landowner Richard Clough and his wife from their honeymoon in 1838. In July 1843 the first annual meeting of the Min-y-Don Court of Ancient Foresters was held at the Ship, where a capital dinner was got up by landlord Mr Foulkes. Following this all the members went in procession to pay their respects to Lady Erskine at Pwllycrochan.

Life was not always this grand, however. In the cold January of 1882 hot plum puddings were on the menu in the Ship; that is, they were until one which was boiling in a saucepan in the kitchen was stolen. Sergeant Thomas Rowlands searched the house of Edwin Jones, the bandmaster of the Colwyn Brass Band, there discovering

The Ship, no longer a hotel.

the hot pudding being pitched into by Edwin, his wife and their four children. The saucepan was later found in the yard of the inn. Both Joneses were remanded on bail, awaiting stiff sentences if found guilty. Although this story has its slight comic element, the underlying nightmare of desperate hunger cannot be denied, and we are in the world that Charles Dickens observed so sharply.

Six years later, the landlord William Pritchard was unfortunately appearing in Bangor Bankruptcy Court. Twelve years later, in 1900, Pierce Davies appeared in the same place. He was a plumber, married to the licensee of the Ship who, it was said, had kept him for many years. He attributed his insolvency to losses on contracts.

The Ship Inn continued in business through the new century, but after a long and at times illustrious history it is now closed as an inn and is being refurbished.

14. The Red Lion, Abergele Road, Old Colwyn

The present-day Red Lion began life as four separate parcels of land. One became the first manifestation of the inn on this site; the second an adjoining cottage, Sun Bach; thirdly, a portion of land next to Sun Bach, curving around the inn; and lastly a small segment of land on what is now Station Road. These passed one by one to various owners of the inn as the nineteenth century progressed

In the 1841 census, publican Robert Williams with his wife Jane, their five children and three servants, were enumerated at the Red Lion, Colwyn. He may have been innkeeper here from 1836, and was the occupier in the Tithe Survey of 1846 when the land owner was John Lloyd. A statement given by William Lloyd in October 1900 says that the Red

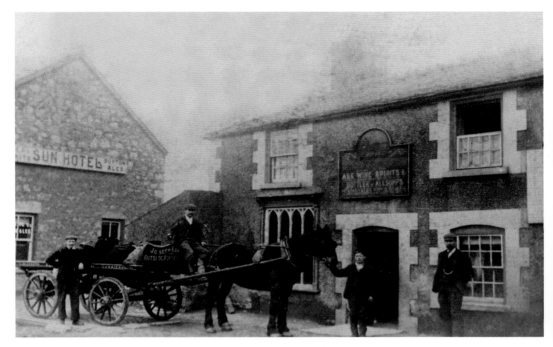

The Red Lion before the rebuilding of 1898, with a cart on the weighbridge.

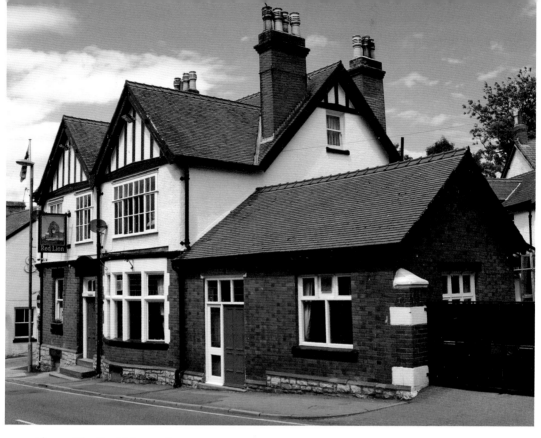

Above: The Red Lion today.

Below: The bar of the Red Lion.

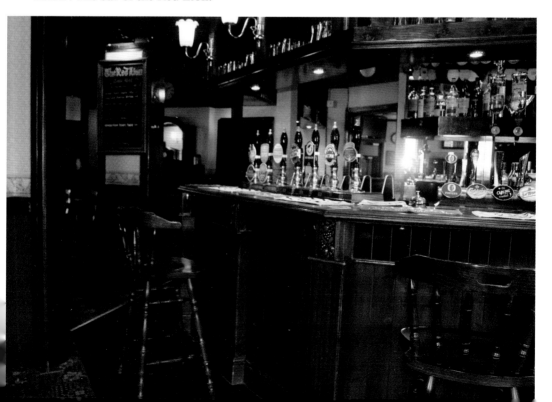

Lion was erected by his father, John Lloyd, who died in 1880. Yet there is no record of the inn in the 1851 census; it appears next in 1861, perhaps suggesting the inn referred to by William Lloyd was rebuilt between 1846 and 1861. However, in 1861 the licensee was Robert Roberts who lived there with his wife Margaret and their four children. We can assume that Robert was a tenant in this year as in 1868 John Lloyd sold the inn to him with the condition that on Robert's death 'no widow should be entitled to dower', that is, she should not inherit her deceased husband's stake in the inn.

Unfortunately for Robert, he enjoyed owning the Red Lion for only eight years. His obituary in the *Wrexham Guardian* in 1876 states that his funeral was one of the largest ever seen in the district. Seventeen days after his father's death, his eldest son and heir Isaac leased the inn to his mother, stipulating she 'should continue to remain a widow'. These requirements may seem surprising to us; regrettably the records do not say why this condition was imposed. In the 1881 census Margaret was listed as head of the household and as inn keeper, living with seven of her nine children (two seemingly dying quite young). The eldest, Isaac, the Red Lion's owner, had the given occupation of carriage driver. With this information we might understand why Isaac so speedily passed on the responsibility of running the inn to his mother. In May 1876 *The Weekly News* had reported that an enterprising car owner intended to run an omnibus between Colwyn and the railway station in the summer months, 'which will be a great boon to the locality' as 'Colwyn much needed something of the kind'. This enterprising individual was Isaac Roberts. In 1885 he sold the Red Lion to his mother; he died on 6 February 1889, unmarried and intestate.

In 1882 Margaret and daughter Jane had bought a shop and premises in Old Colwyn for £400, and in 1886 two cottages in Penmaenrhos, adding another in 1892. Clearly she had made a small empire for herself. This prosperity is implied when we read that in 1881 her son Robert qualified in Glasgow for the Diploma of the Royal College of Veterinary Surgeons, specialising in horse and cattle pathology, going on to win the organ exhibition at St David's College, Lampeter, in 1892.

In 1893 Margaret leased the Red Lion to Allsopp's Brewery for twenty-one years. She sold them the weighing machine which was just outside the inn in 1898. In that year Allsopp's rebuilt the inn and George Sanderson was landlord, taking the licence in 1894, though by trade he was a clerk. He had married Margaret's daughter, also named Margaret, in 1885 and so, for a while, the Roberts' maintained a connection with the Red Lion. The music connection also continued, his eldest daughter Mary becoming an Associate of the London College of Music in 1907.

Allsopp's sold the premises in 1922 to a private owner; three years later it was acquired by Threlfall's Brewery. It returned to private ownership in 1994 and continues to serve fine ales in pleasant surroundings.

15. The Plough Inn, Abergele Road, Old Colwyn

26 April 1838 was a good day for the hostelry business, though there was to be a sting in the tail. On this day much festivity and rejoicing took place in the little village of Colwyn (as Old Colwyn was then known), for Richard B. Clough and his lady had returned from their matrimonial tour. In the morning, church bells rang out and the

village was bedecked with seventy flags. By the afternoon a large crowd of villagers enjoyed a sumptuous dinner at the Ship Inn. After this, and preceded by a band of music, they marched two miles or so to meet the happy couple at their residence, the grand Min-y-Don Hall, arriving about 5 p.m. They were met by men on horseback who led the revellers through a newly erected triumphal arch, surmounted with a lion and two flags; once through the arch they were regaled by their wealthy host, returning afterwards to the village where every cottage was lit up in a brilliant blaze that stretched as far as the eye could see. For the rest of the evening the band played on outside the Ship Inn and the party spread to the Red Lion and The Plough.

However, inn-goers were not the only participants in that day's celebrations. In the afternoon, after leaving the Ship Inn, the procession had been joined by a large band of teetotallers carrying a splendid new flag. As the festivities continued into the evening the teetotallers distributed eighty ounces of tea and a quantity of bread to the poor of the village; a sheep, the gift of Lord Mostyn, was also given. As the party progressed (and we might imagine that it would now be in rather full flow) the opportunity was taken at the nearby Temperance Hotel to discourse on the advantages of sobriety.

This colourful glimpse into a rare day of celebrations for the village suggests that the inns of Colwyn were a central part of the community – teetotallers apart, of course. It may also suggest that, then as now, particular inns had their own clientele, for once the main events at the Ship were concluded some retired to the Red Lion and some to The Plough.

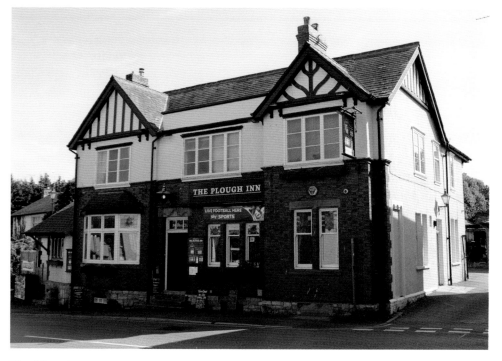

The Plough.

The Plough is listed in the 1841 census but licensee Daniel Wynne's occupation is given as wheelwright, probably a reflection of his dual role: that of landlord and keeper of the stables. The Tithe Survey map of 1846 shows The Plough at the end of a terrace of eleven extremely narrow cottages. The landowner of The Plough at this time was John Lloyd Wynn, with Daniel still as occupier and landlord. Although small, the building did have 30 perches (about 760 square metres) of land attached to its far side. In the 1851 census Daniel is recorded as innkeeper, though now the name The Plough is not recorded: his address was No. 1 Row Street. Later in the century it was reported that the terrace had six cottages; even then – assuming that each was the result of knocking two through to make one dwelling – they had very restricted space inside.

By the 1850s, this small inn was a regular centre for picking up catalogues for auctions of land, furniture and other goods. It was also a venue for dinners: on Whit Sunday 1875, after attending divine service, the Samaritan Club dined there while the Colwyn Band played a selection of music.

A fairly common feature of pubs and inns during the nineteenth century was the number where the licensee was a woman. In 1875 John Davies of The Plough Inn married Elizabeth Foulkes Lloyd, widow and landlady of the Ship Inn. Elizabeth's first husband, another John, was a local farmer in 1841 and by 1851 they were installed at the Ship, though she was the innkeeper and he remained a farmer. She was widowed before 1861 but kept on running the inn single-handedly until 1875 when, at the age of seventy-two, she married John, aged fifty-six, of The Plough.

Foulkes is a name frequently encountered as licensees of pubs and inns of the district. Whether because this was a common local name or through a family tradition of working in the trade is not certain. However, possessing that name was not always a sign of success. In 1903 there was a remarkable case of bankruptcy and strange money-lending activities concerning the tenant of The Plough from 1900, Robert Evan Foulkes. It was only at the end of a lengthy hearing that he admitted he had lost money through gambling.

In more recent times The Plough was rebuilt, originally with several small rooms. It now has a large bar with a separate dining area and a side room, and is conveniently situated across the road from a car park.

16. Sun Inn, Abergele Road, Old Colwyn

As far as records can tell the Sun Inn was built after the Red Lion, the Ship Inn and The Plough, all of which have verifiable, indeed overlapping, records from the 1830s. The Sun was built around 1844, probably in connection with the influx of navvies (who were not necessarily all Irish) constructing the railway line being extended across North Wales. Uniquely among the pubs and inns of Old Colwyn erected prior to 1870, the original building remains, the others having been rebuilt during their history. The 1846 Tithe Survey details the Sun as the present building with 17 perches (430 square metres) of land, which was very small when compared against the Ship Inn's 1 rood and 24 perches (7,020 square metres) of land and stables. The first census record of the Sun appears in 1861, raising the question of whether it was an inn during 1851, or if this census is incomplete. In 1861 the licensee was John Jones, and his recorded occupation was victualler.

By 1871, John was still at the Sun Inn but now he listed his occupation as farmer and publican employing two men. John had left the Sun by 1881; by then William Jones was the occupier though his occupation was given as joiner, with no mention of anything inn-related. John and William's occupations may suggest that the Sun was not always the main source of income for its residents; this might explain the inn's omission from the 1851 census and the lack of reports in contemporary newspapers. It was certainly a licensed premises in 1885, when the licence was transferred to George Sanderson – who also had a dual occupation, this being clerk and innkeeper. In 1894 George left to become tenant of the Red Lion next door. However, his tenure at the Sun was not without difficulties as in 1892 he had trouble obtaining the annual licence. In 1901 the licensee was Arthur Bennett, who resided with his wife and young daughter, two servants and his niece Letitia Roberts, aged nineteen, enumerated as tobacconist and assistant; we might assume that the smoke room lived up to its name.

Under Arthur's tenure 'a novel arrest' was reported in November 1903. John Turner went for a quiet afternoon pint and dinner in the Sun and was the only drinker in the bar. When he left the landlord had a suspicion that all was not well and followed him to the post office, where a box of cigarettes and a bottle of whisky were discovered under Turner's coat. The landlord promptly marched him down to the police station, but the constable was away at the assizes so Arthur had to lock up the thief in the cell himself. When the officer returned he found the whisky bottle – still in Turner's possession – a quarter empty, and the prisoner helplessly intoxicated. When charged with the theft Turner replied, 'It's enough to make a man do anything, this wet weather.' His subsequent sentence for this theft was fourteen days imprisonment with hard labour.

A year later Arthur had taken over the Telegraph Inn, on the summit of Great Orme's Head, and Frederick Owen became landlord of the Sun.

Comic incidents and harsh punishments notwithstanding, two themes emerge from this narrative. The first is that inns and pubs could change hands frequently. The second relates to the growing concerns the authorities had about licensed premises in general.

Throughout the Conwy district from the 1890s there are innumerable references in the local press to individuals being arrested for being drunk 'while in a public house', or for drinking on a Sunday; drink and drunkenness continued to be a major national concern up to the First World War. By 1898 this issue was exercising the gentlemen of the English Congregational Church, Old Colwyn. On 7 September that year they opposed an increase of licenses on the grounds that drunkenness was the chief cause of pauperism for many, which led to applications for Poor Relief. Whether they were concerned for those receiving Poor Relief, or for their own pockets (as they were among the ones obliged to provide the greater part of the Poor Rate), we cannot tell. The local Superintendent of Police reported that there was one fully licensed house for every 383 houses (there were also five off-licences); in the previous year there had been ninety-seven convictions for drunkenness. The outcome of all this is that licences were increasingly not renewed or were revoked, possibly providing a link between the revoking of licences and the merry-go-round of licensees.

Nowadays the Sun Inn retains its 1844 exterior and has original features, such as a bar dating from the 1930s, and is thought of as a 'locals' local'.

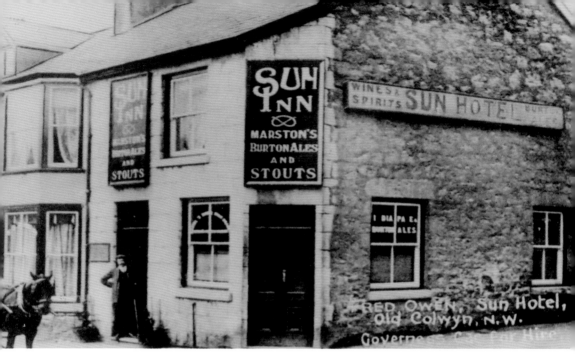

Above: The Sun Inn, 1910.

Below: The Sun Inn today.

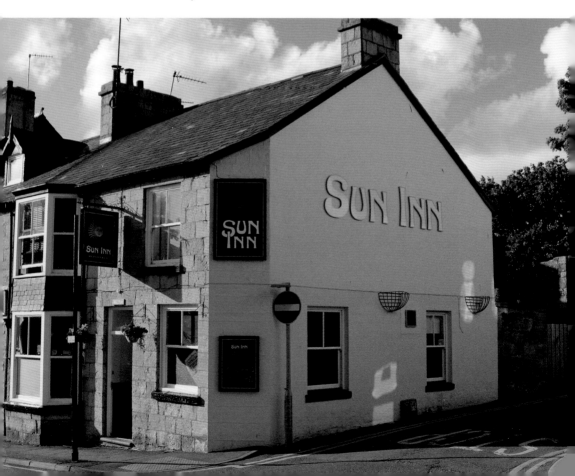

17. Marine Hotel, Abergele Road, Old Colwyn

20 May 1875 was party night at the Marine Hotel. Much toasting, speeches and general jollity followed an excellent dinner, for on this night the proprietor Mr Roberts invited distinguished guests to celebrate the opening of the recently completed hotel. Unfortunately the party atmosphere did not last long. Later that same year Mr Roberts was appearing before the bankruptcy court in Bangor where there was much arguing between his legal representative and his creditors. It transpired that Mr Roberts had borrowed money in 1873 to pay for land in Colwyn on which to build the Marine Hotel and nearby houses. In 1874 he ran out of money and mortgaged the property, and it was these creditors (especially the main protagonist, Mr John Griffith, jeweller, of Caernarfon) who were chasing him for interest on the money loaned. Unfortunately, Mr Roberts did not have the funds to pay them. The party was over.

In June 1876 the hotel was advertised for immediate let, its main selling point being that it was only four minutes' walk to the beach. Three months later Janet Browning leased the concern for fifteen years. Tellingly, the lessor was Mr J. Griffith, a jeweller from Caernarfon. Her rent for the hotel was set at £70 for the first three years, £90 for the next five, and £110 for the remainder of the term. This gradual rise in rent may signal that she was expected to build up custom and income, which is possibly why she added the billiards room in 1878 – which also increased her rent by £25 a year.

Janet was probably an unusual proprietor for Old Colwyn in those days because she hailed from Scotland. In common with other licensees in the village, she was both a widow and the landlady, or, perhaps better, hotel-keeper. During her tenure of the Marine it became a centre for lavish formal celebratory dinners, such as the one in 1886 when the architect, builders and others were 'treated to a most sumptuous repast' by Messrs Smith, for whom they had erected the new mansion at Parciau.

By 1893 Janet had left and 'the well-known hostelry the Marine Hotel' was once again on the market. It was taken on by Margaret Lloyd and her husband John that September. Margaret continued the tradition of grand dinners, such as that for the Trades Supper in December 1899 for those building St John's church. The menu comprised vermicelli soup, filleted soles and anchovy sauce, roast beef, roast turkey and bread sauce, roast pork and apple sauce, plum pudding, apple tarts, mince pies, jam tartlets, cheese cakes, jellies, blancmange, cheese and dessert. This was taken in the billiard room, 'which formed an excellent concert-room' for the singing which followed. Other members of society were not forgotten; for Queen Victoria's Diamond Jubilee in 1897 the aged poor sat down to a meat tea. In 1898 the same group was treated to a supper, after which, 'and to their delight', a smoking concert was arranged at which the women had cakes, oranges and apples. We can assume that the hotel's dog was safely tethered away during this function as it was reported that it was an 'immense brute', whose 'ugly face' was familiar to everyone passing the hotel.

Improved postal services came to Old Colwyn in 1905 when the Marine Hotel became the place to post letters. Indeed the twentieth century was arriving fast, especially on the road outside the hotel. The days when it was newsworthy to report that the local butcher had been thrown off his bicycle by a sheepdog while trying to avoid a herd of sheep were fading rapidly. In 1909 local teacher Miss Lottie Owen

Above: The Marine Hotel around 1904.

Below: The Marine Hotel today.

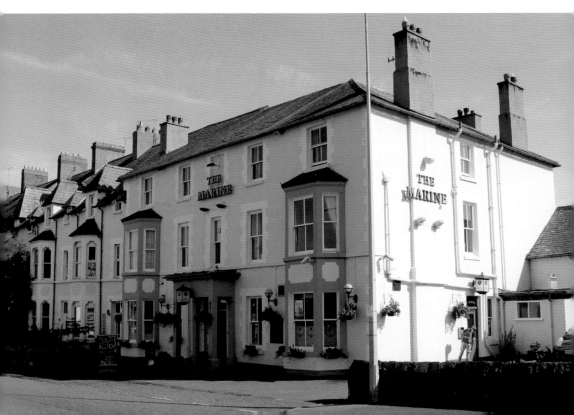

was riding her bicycle to school when she heard a strange noise behind her. In turning round she saw a motor car, and not knowing what to do next she became unnerved, lost control of her bicycle and crashed into a lamp post. Fortunately she was not hurt, only severely shaken, and so rested awhile in the hotel. This was sadly not the case for a small boy named William Edwards who that year received head injuries when his bicycle crashed into a motor car on its way to Colwyn Bay. On impact the car driver suddenly swerved, breaking the front axle. The car's passenger, a rather huffy Julius Pisko, Austro-Hungarian Consul General, said that the accident had been the boy's fault as the car was 'only going about nine miles an hour'.

It was perhaps a pity for those involved in these accidents that Marine licensee John Lloyd's invention had not been around earlier. In 1910 he patented a brake for carts and other vehicles which was attracting much attention at events such as the Old Colwyn Show and further afield in Denbighshire and Flintshire; orders for the device were 'coming in steadily'.

A century later the Marine Hotel remains a popular venue for both guests and locals, with two bars and a menu to serve all tastes. It also hosts well-attended quiz nights and other events.

18. The Station, Station Road, Colwyn Bay

In 1848 the railway came to what is now Colwyn Bay when a station, named simply Colwyn, was opened. Its name was changed to Colwyn Bay in 1876. Another railway station, around a mile further to the east, was opened in 1884: rather confusingly called Colwyn Station, its name was changed to Old Colwyn the following year to help passengers avoid alighting at the wrong stop. Eventually it was deemed excessive to have two railway stations essentially serving the same town, and Old Colwyn station was finally closed in 1964.

Colwyn Bay station, though, remained, and the first Station Hotel would have been visible from it across a field thanks to a gas lamp at the top of Station Road that had been presented by John Porter, the town's principal architect; both the lamp and the Station Hotel appeared on the first edition Ordnance Survey map in 1875.

Built around 1870, for many years the Station Hotel and Imperial Hotel, separated by farmland, were the only buildings on that side of Station Road. Constructed of local carboniferous limestone in a style vividly described as 'muscular Gothic' – resplendent with bay windows on different levels, hipped roofs and decoratively sculpted multiple chimneys – the Station Hotel is important as being one of the few remaining examples of the town's early development as a resort.

The building had six entrances in the 1890s, a time when being drunk in a pub was an offence. Although this arrangement would have been useful to patrons who had imbibed one too many, enabling them to escape through one door if a policemen entered through another, it evidently displeased the authorities as some of the doors were subsequently blocked up.

The hotel was bought at auction in 1888 by experienced local hotelier John Owen, and included a warehouse, bottling stores, livery stables and an adjacent building called Central Chambers. By 1891 the name had been changed to the Central Hotel; the local press

reported in that year that a former barman of the establishment had been charged with stealing a gold watch from a local woman. In April 1896 the hotel – by this stage owned by the Soames Brewery of Wrexham – provided beds for the crew of a schooner who had been rescued by the Llandudno lifeboat when their vessel foundered off the coast of Colwyn Bay. A reported 2,000 people lined the promenade to welcome them ashore.

The hotel was sold to Ind Coope & Co. in 1900 for £10,000, and in 1906 work began to extend the pub sideways along the adjoining Conwy Road. The work cost £3,000; stained glass art nouveau windows from this development still exist in situ. During the extensions, workmen discovered a dried-up well some 10 metres deep. This delayed proceedings considerably and the builder lost a lot of money on the contract, going bankrupt the following year.

The Central continued trading throughout the twentieth century, although it stopped offering accommodation during the 1960s and operated solely as a pub, with a nightclub in its cellar in later years. By the early twenty-first century it had become increasingly run-down, and a grant was awarded by the town's heritage initiative to renovate the building as part of a wider regeneration project in Colwyn Bay. The grant was supplemented by funding from other sources, including parent company Enterprise Inns and the new owners; work began in December 2014. The exterior was overhauled with the help of old photographs, and the ground-floor interior was opened up to create more space. During the interior renovations several articles were discovered, including coins, old milk bottles and a local apple-seller's crate. The former hotel bedrooms on the second floor, which had been closed up and the access staircase removed, were discovered exactly as they had been left, complete with old boots, posters on the walls and newspapers dating from the 1960s. These were then resealed and left intact.

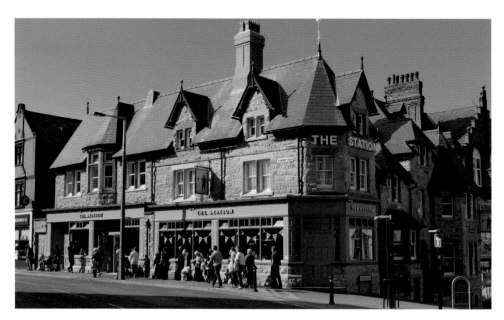

The Station, for many years the Central.

The total renovations cost some £600,000 and the refurbished pub opened in May 2015 under its new (and old) name of The Station.

19. The Picture House, Princes Drive, Colwyn Bay

Pub chain J. D. Wetherspoon has a knack for reclaiming redundant buildings and renovating them to an imaginative approximation of their former glory, and the Picture House is no exception.

Built in 1914, it opened as a cinema named the Princess Picture Theatre in October 1922. Seating was initially on one floor; in 1932 a balcony was added to bring the seating capacity to 800. In the same year the building acquired a new neo-Egyptian façade, a style very popular in the art deco years of the 1920s and '30s largely due to the discovery in 1922 of the fabled tomb of King Tutankhamun. The interior was also given an Egyptian-style makeover. Some cinemas of this period had such lavish interiors – some were even grand enough to have their own orchestras and cafés – that they were popularly known as 'picture palaces'.

For the first forty or so years, the cinema was owned and operated by a Mr Kenyon and his son, George. They also owned another picture house, the Cosy Cinema, a few hundred yards away. However, they only employed one projectionist, who at busy times (so it is rumoured) was obliged to run up and down the road to change the film reels. The Second World War, when the Ministry of Food was relocated to the town, was an especially busy period, with matinees on Wednesdays and Saturdays and two evening showings every day. Fortunately for the projectionist, it was closed on Sundays.

At some stage it was renamed the Princess Cinema, and in 1976 it was taken over by the small Hutchinson Leisure chain until 1981, when it closed as a cinema and then

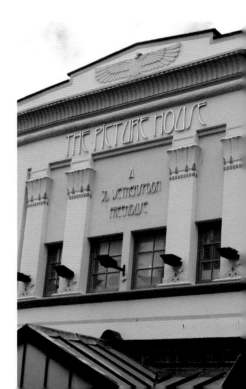

The Picture House.

reopened as a bingo hall. It acquired Grade II-listed building status in 1994, when it was listed as the Princess Bingo and Social Club – something of a comedown from its original rather grand title.

Bingo left the building in August 1997, when it was sold to Wetherspoons and renovated to its previous appearance (minus the cinema seats). It opened as The Picture House in September 1998.

Thirty years ago, there were four cinemas in Colwyn Bay. Now there is none. However, the almost intact art deco exterior and interior of the Picture House ensures that something of the golden age of the silver screen remains in the town.

20. Pen-y-Bryn, Upper Colwyn Bay

In 1865, the Pwllycrochan estate was sold by Sir Thomas Erskine to Manchester businessman John Pender for the princely sum of £26,000. The sales brochure for the estate, which encompassed the Pwllycrochan mansion and gardens along with farm buildings and 700 acres of land, described it thus:

> The property commands one of the finest marine prospects in this most popular neighbourhood, with a splendid sea bathing beach 1¼ mile in length forming a perfect amphitheatre. The mansion will be sold in one lot and the remaining portion will be sold in separate lots to meet the great and increasing demand for marine residences on this coast.

Pender had intended to develop the land as a seaside resort to cater for the affluent classes of Liverpool and Manchester, but financial difficulties meant he sold on the entire estate ten years later. Much of the land was bought by a consortium of Manchester businessmen who went on to found the Colwyn Bay and Pwllycrochan Estate Company, which remained in Colwyn Bay until 1973 and was instrumental in growing the area into an important town and holiday destination. By 1921, it had gone from being fields and woods to having a population of 21,566. The mansion's freehold, however, was purchased by Pender's agent John Porter, who converted it and ran it as the Pwllycrochan Hotel. The Porter family continued operating it as 'a first-class family hotel' until 1938 when it was sold to Rydal School. During the Second World War it was taken over as one of the bases for the Ministry of Food, which commandeered all the hotels and private schools in the town. In 1953, it became the base for Rydal's junior department, now Rydal Penrhos Preparatory School.

An advertisement in 1916 describes the hotel as having such enticing delights as electric lights, lifts, lock-up garages and close proximity to the eighteen-hole Colwyn Bay golf links. The golf club, founded in 1893, used as its clubhouse the former home of John Porter – the original owner of the Pwllycrochan Hotel – which was situated above the hotel.

Membership of Colwyn Bay Golf Club dwindled during the 1950s; in 1958 the local council purchased the site, selling it on for development in 1960. It became what is now Colwyn Heights; some of its original road names are named after well-known golf courses (St Andrew's Road, Troon Way, Wentworth and Sunningdale Avenues) as a nod to its former incarnation.

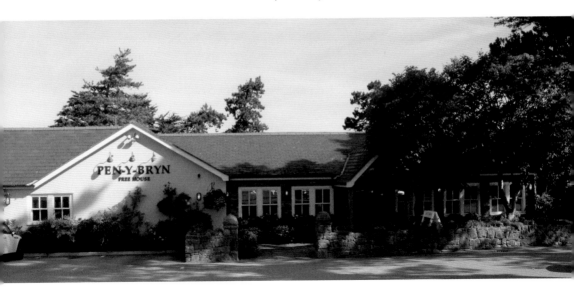

Above: The Pen-y-Bryn.

Below: The bar of the Pen-y-Bryn

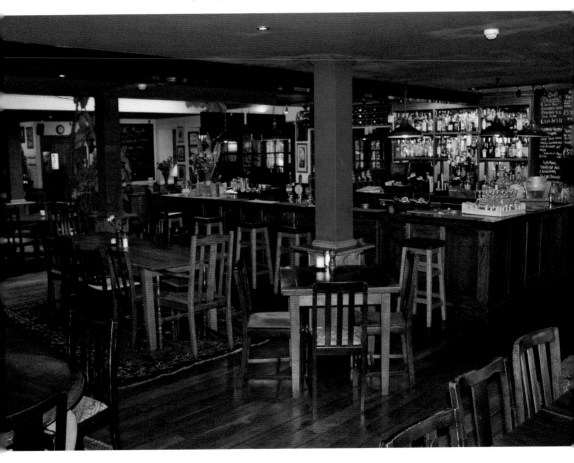

In the late 1970s David Taylor, the manager of a pub in Colwyn Bay, bought the land where the former clubhouse had stood to build his own pub. The building was constructed using bricks and other materials from properties which had been demolished in the early 1980s to make way for the new A55 dual carriageway. Opening in 1983, the new pub and restaurant was named Taylors.

David Taylor sold his eponymous pub in 1998 to Ray Perry, who in turn sold it on to Brunning and Price, a family firm with a portfolio of pub restaurants mainly in North Wales and the North West of England. After an extensive refit it was opened in June 2001 as the Pen-y-Bryn. Despite the exterior being described on Brunning and Price's website as looking 'a bit like a medical centre', the interior is classic comfy pub with oak floors, open fires and old furniture. Perhaps its crowning glory, though, is the spectacular views from its terrace and garden windows, summed up thus in a post-war official handbook of the golf club, 'Few courses in the United Kingdom offer a finer panoramic view of mountains, moor and sea than Colwyn Bay Golf Club.'

21. Hickory's Smokehouse, Llandudno Road, Rhos-on-Sea

When researching pubs and inns using only written records it is assumed that a named establishment will always occupy the same site. However, some of the hostelries researched for this book have raised the suspicion that this assumption might not always be valid; the Ship Inn is one such example. The first illustration shows the Ship Inn as it was some time before 1873. It is shown to be directly in front of the gates of St Mary's church, with the vicarage to the right of the inn. In the next, from the early 1900s, the Ship Hotel, as it was then, has moved down the road to its present position and has been rebuilt.

The earlier illustration may also raise a wry smile – the inn has been given precedence over the vicar's residence in terms of location. The close connection between a church and an inn occurs quite frequently. From the seventeenth century onwards, churches through their vestry meetings assumed many of the old functions of the manor for their parish; for instance, it became responsible for appointing the local constable, administering the Poor Law and maintaining the highways. As the only other 'public houses', inns were the venue for meetings of a different kind, such as the paying of rents and wages, for meetings between landlords and tenants, and for organisations which operated privately, such as landowners' groups. The church and inn thus had complementary roles in the running of the parish. This relationship faded from about the middle of the nineteenth century as affairs began to be administered by parish councils, finally ending in 1894. Whether coincidental or not, by this date the temperance movement was also very active and the general image of alcohol-serving establishments could have played a role.

The original Ship Inn was built in 1736 and was in business in this location until 1874, when local landowner Whitehall Dodd demolished the building and rebuilt it as the Ship Hotel in its present position, probably ending its connection with the church. Nonetheless, its role as a central place for conducting business continued. In June 1904 an auction of property was held there 'before a large and representative audience'. Up for sale was Pencreuddyn Villa and three acres of pasture land on the old Llandudno to Colwyn Bay road belonging to Mrs Beasley, who had moved to Llandudno. The lot

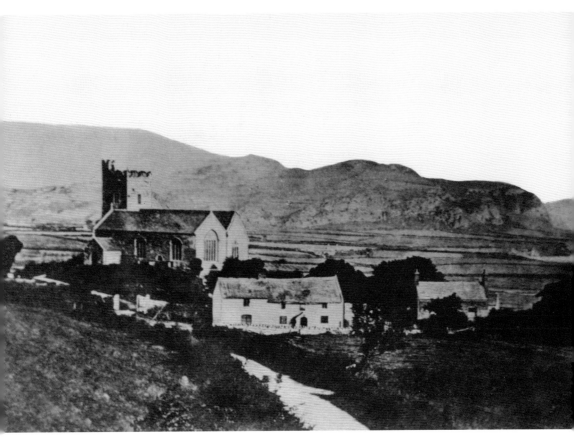

Above: The Ship Inn before 1873.

Below: The Ship Hotel in its new location, around 1905.

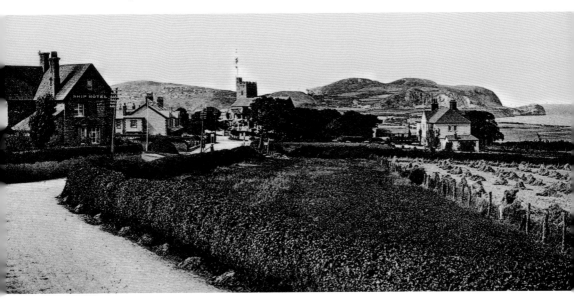

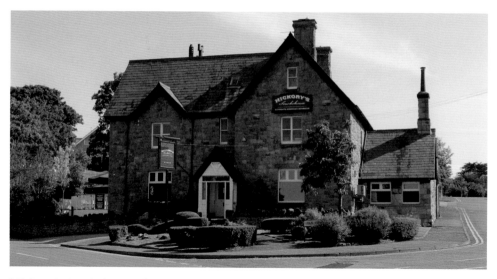

Hickory's Smokehouse, formerly the Ship.

went for £810 to John Jones of Dinarth Hall who owned the adjacent property. This auction was, then, quite an upmarket event.

Whether the local police would have always agreed that the Ship was upmarket is probably doubtful. Around 1895 they were concerned that the licence holder did not live on the premises, but more than that, they had repeatedly informed the licensing authorities that the pub had a number of back doors through which drunks could escape when they approached. An establishment having several escape routes is a situation often encountered in pubs and inns of the district. The police were pleased to report in September 1895 that the back doors had been closed off and that they now had nothing to complain about in that respect.

Although most of the Ship's landlords were locals, in 1910 the licence was transferred to a man from Huddersfield – a Mr Walter Nelson Butler. Much more recently its identity, though not its location, changed again in 2014 when it was renamed Hickory's Smokehouse, serving an authentic American BBQ menu in the restaurant.

22. Cayley Arms, Rhos Promenade, Rhos-on-Sea

The small town of Rhos-on-Sea lies to the west of Colwyn Bay and is now effectively a suburb of that town, having grown and developed at around the same time in the late nineteenth century.

The Cayley Arms was originally called the Blue Bell Inn, or Hotel. The later name for the pub takes its name from the Cayley family, who were prominent landowners in the area. Other local roads, similarly hat-doffing in their names, include the Cayley Promenade – raised above the main sea road and separated from it by a broad, grassed bank – as well as Kenelm, Allanson and Everard Roads. Brompton and Ebberston Roads take their names from former Cayley estates in Yorkshire. Most of the family's property in Rhos-on-Sea was sold in 1935.

In 1904, John Roberts brought a case of damages against Mr Darlington, the landlord of the Cayley Arms. Both men had been part of a shooting party when there was an unfortunate incident involving Darlington, Roberts and a rabbit. Roberts was shot in the left hand: one and a half pellets were extracted from it after surgery and he subsequently 'absolutely lost the use of the finger'. (It was not reported whether the rabbit itself was shot, or made good its escape in the ensuing melee.) After deliberations that lasted an entire day, the jury at Caernarfon Assizes eventually decided the affair had been a 'pure accident', with no negligence on Darlington's part, and awarded Roberts £100 in damages – no mean sum of money for the time.

The Cayley Arms was once again the centre of high drama in 1907, when the local press reported that a horse harnessed to a soft drinks float had galloped off by itself along the Marine Drive. In somewhat breathless prose, the report states that there were many fruitless attempts to stop the horse; it had safely negotiated the awkward corner at the bottom of Rhos Road before dashing through the narrow passage by the Cayley Arms Hotel, 'cleverly missing three lorries and a landau which lined one side of the passage'. One brave soul endeavoured to climb up onto the float, but gave up when he noticed the reins were trailing along the ground. The intrepid steed carried on, float still in tow, until it reached the stables in Colwyn Bay 'without, so far as can be ascertained, doing any damage', which was doubtless a relief to all concerned.

The most eminent member of the Cayley family was George (1773–1857), later Sir George, a notable scientist, engineer, inventor and all-round polymath. As well as inventing the caterpillar tracks which were later used on military tanks, and a self-righting lifeboat, he also designed an artificial hand for one of his tenants. His most enduring legacy, though, is his discovery of the key principles of aeronautics. Fixated with the notion of designing a practical flying machine, in 1853 he built a glider that could carry the weight of a man. Subsequently dubbed the Cayley Flyer, it flew for 275 metres across Brompton Dale in Yorkshire before crash-landing. Sensibly, at the age of eighty Sir George did not man the glider himself, but instead gave that duty to his coachman who promptly resigned following this alarming experience, muttering (or so it is reputed) that he was hired to drive, not to fly.

Nonetheless, this was the first recorded flight in history of a fixed-wing aircraft; coming as it did some fifty years before the Wright brothers' powered flight in 1903, it is fair to describe Sir George Cayley as the true inventor of the aeroplane, and the Wrights themselves later acknowledged how Sir George and his flying machine had paved the way for their own achievement.

The current pub sign for the Cayley Arms depicts a portrait of Sir George, along with some of his early sketches for his prototype flying machines; a small tribute to a man whose contribution to the world of aeronautics is today largely forgotten.

23. Rhos Fynach Tavern, Rhos Promenade, Rhos-on-Sea

Rhos Fynach has a thought-provoking history. A recent report by Clwyd-Powys Archaeological Trust notes that it is a Grade II-listed building dating from 1717, though it has earlier origins, probably fifteenth-century.

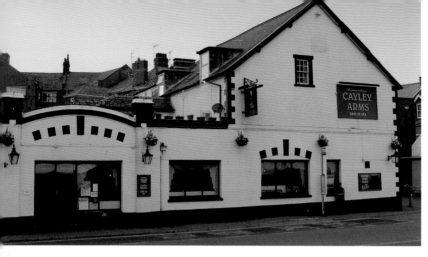

The Cayley
Arms.

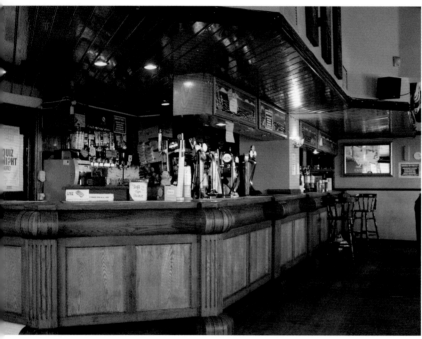

The bar of the
Cayley Arms.

Rhos Fynach
around 1900.

Written sources before 1841 for Rhos Fynach are difficult to pin down. Reports from the nineteenth century refer to the celebrated ancient fishing weir which lay close by: for example, an article in 1874 on the large number of salmon caught in it (and by the dog Spratt, son of the famous Jack), three of which were donated by the owner to the aquarium in Manchester.

The 1841 census records Rhos Fynach as a farm owned by Margaret Parry. The head of household was away on the night of the 1851 census, though a servant named John Parry was recorded in both. By 1861 John Lewis Parry Evans farmed Rhos Fynach with its forty-eight acres of land, and although married, lived alone with three servants, one of whom was John Parry, now a cowman. In 1871 Parry Evans resided in Rhos Fynach with his wife Elizabeth, five children, his sister-in-law, a nurse-maid, and three servants. He was now a yeoman and owner of the fishing weir. In 1872 his sister-in-law became a partner in the National Provincial Bank of England. Clearly, the Parry Evans household was doing rather well. They remained at Rhos Fynach Farm in 1881, though the landholding had decreased to thirty-five acres due to selling off land on which was built the Rhos Abbey Hotel. Parry Evans sold the farm through auction in October 1882 and by 1891 resided at No. 8 Seaview Terrace, Rhos, living then 'on his own means' with three of his daughters. He died on 18 December 1894, aged seventy-four.

The resident and cultivator of Rhos Fynach Farm in 1891 was David Roberts, with family and servants. In February 1892 the Colwyn Bay Pier Company registered a capital of £30,000 for the purchase of freehold land 'known as Rhos Fynach Farm and the Rhos Weir', to 'construct and maintain a marine pier and promenade, jetty, and landing-place'. By 1900, and in keeping with the growth of Rhos as a resort, Rhos Fynach Farm was at the beginning of its career as a guesthouse, cafe and restaurant. It was also starting to be known as Rhos Fynach Monastery.

At this time a number of reports and texts of a different nature began to appear. The first reference to any religious activity in the area appears to be the naming of the Rhos Abbey Hotel, which local press reported as being recently opened in June 1899. On 30 December 1898 the *North Wales Express* reported the find of a hoard of Roman coins from the 'old abbey garden of the Rhos Fynach Estate'. The coins themselves are now lost, but it appears that they were from the period of Constantine I (AD 306–337), the emperor who made Christianity the state religion of the Romans. Something was afoot early in the fourth century as two other hoards of Roman coins from this period have been discovered locally, though why their original owners buried them is lost to time. The newspaper report then changes gear and tells its readers that the whole district 'abounds with historic settlements and events', that it all formerly 'belonged to the Roman Catholics' and that the fishing weir 'was the oldest on record' and constructed by 'the Monks of Rhos Fynach'. Furthermore, the article continues, it was from this abbey that Prince Madog 'sailed in 1160 to America' and so was 'the first to discover the New World', the source for this being 'Caradoc's *History of Wales*, translated by Humphrey Llwyd 1584'. It further informs that the earlier history 'was compiled from registers made by bards of the Principality and deposited in the abbey.'

These themes of antiquity were picked up by three local ministers. 1904 saw the publication of Revd W. Venables Williams' history of the parish; in September

1907 Revd M. J. Hughes, vicar of Bryn-y-Maen, translated from Latin into English 'the ancient and famous Rhos Fynach Charter'; and in 1910 a small souvenir of Llandrillo-yn-Rhos, including a history of Rhos Fynach, was published by the Revd T. E. Timothy. These authors tell us that they had consulted, translated and compiled a number of ancient and complex texts (such as charters of Welsh kings and Cistercian repositories) dating from the thirteenth century onwards. They record that Rhos Fynach Farm, built in 1181, was linked to the Cistercian monastery of Aberconwy. It had secret tunnels linking it to the tiny sixth-century St Trillo's chapel located on the seashore, where the monks had responsibility for the fishing weir. When Henry VIII dissolved the monasteries Rhos Fynach reverted to being a farm. Somewhat later, a 1575 charter from the Earl of Leicester granted all lands and fishing rights of Rhos Fynach to a Captain Morgan (a privateer, not the notorious pirate of the same name) for sixpence, as long as the captain dealt at sea with the enemies of Elizabeth I.

By 1910, the area and the old farm had become an attraction worth visiting with pilgrims coming from far and wide. Some were more local such as the Llandudno and District Field Club who visited in March 1910 to explore, among many other antiquities, 'Rhos Fynach, the Cistercian Abbey of Aberconwy'.

Unfortunately, by the 1970s Rhos Fynach had decayed to such a state that the Borough Council wished to demolish it; however, it became part of the Blue Dolphin complex with an open-air swimming pool and café. After some renovation it reopened as tearooms, but became dilapidated again and in the mid-1980s was boarded up and abandoned. In 1990 a Llandudno businessman signed a 99-year lease for the site, and rebuilding and renovation work began. It opened in 1992 as the pub/restaurant we see today, a place many know as well worth a visit for its atmosphere, food and drink – as well as its history.

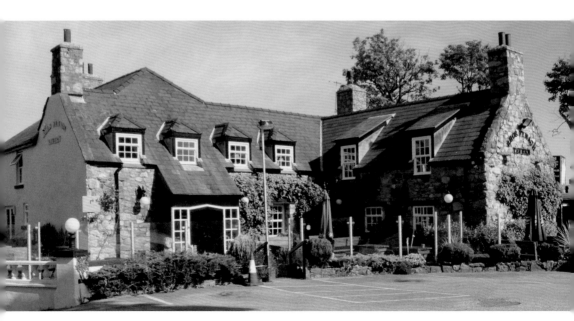

Rhos Fynach today.

Around Llandudno

24. The King's Head, Old Road, Llandudno

The King's Head is the oldest pub in Llandudno. It is likely that it was built during the reign of George III (1760–1820); a surviving account book of the landlord, William Owen, records details of goods and services supplied on account to named customers. This book also contains two pages summarising vestry meetings that were held there. These records cover the period 1823–28; it can be assumed that the pub had been in business some time before this, and therefore that George III possessed the head in question.

The account book takes us back to a time when many, especially small, transactions were on account; the carrying of loose change about the person was not regular practice until well into the nineteenth century. It records bar bills of four shillings (20p) for twelve pints of ale and that a day's eating – breakfast, dinner and supper – could be had for three shillings (15p). The vestry meeting minutes show a concern for locals in need, documenting the distribution of 'wearing apparel for the poor' and settlements on account for illegitimate children. They also show that gifts of ale were quite common – presumably because of its beneficial properties rather than the meetings being held in the King's Head.

In these early days Llandudno was a sparsely settled area focused on the Great Orme's mining and quarrying activities; the plain below was largely saltmarsh and common grazing. One story concerning the King's Head in this period is that the miners would be paid quarterly, and that each pay day one would pin a pound note on to the chimney piece in the parlour; when this was all spent another would do the same. Unfortunately for this story, one- and two-pound notes were issued only briefly by the Bank of England in a few years up to 1821, when gold sovereigns took their place. Private and joint stock banks were also prohibited from issuing notes. It is most unlikely that some sort of locally-issued promissory note was in circulation. A further consideration is that in the nineteenth century those less educated – illiterate, in other words – were easy prey for forgers and so were suspicious of paper money, preferring coins with a known intrinsic value. Simply possessing a forged note, let alone pinning it on a highly visible chimney piece, was punishable by transportation or death.

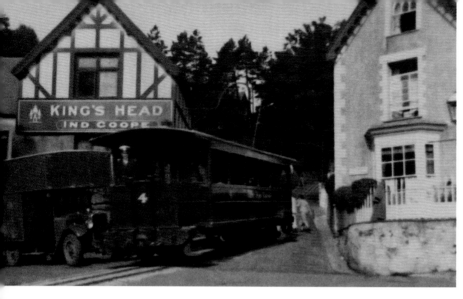

The King's Head with Tram 4, St Tudno, passing by.

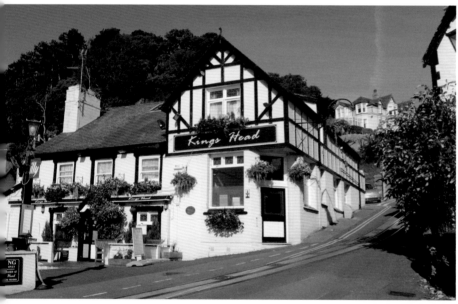

The King's Head today.

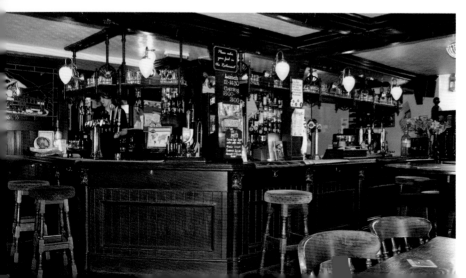

The bar of the King's Head.

Probably through the pressure of financial difficulties Lord Mostyn, a large landowner in the area, began the process of applying to Parliament to enclose the land on the plain. The sought-after Enclosure Act was granted in 1848, and by 1849 the foundations of the development of Llandudno were in place. Unluckily for those too poor to be eligible to elect MPs, and had no voice to express their grievances, they were quickly ousted from their homes to make way for 832 allotments for the building of the new town. Over the next thirty or so years Llandudno expanded rapidly.

Already by June 1843, predating the developments, the King's Head was the place to come to buy tickets from Mr Owen for a voyage on the Dublin-based ship *Erin-go-Bragh* for a 'safe and expeditious steam communication between Menai Bridge and Liverpool (calling at Llandudno, weather permitting)'. The nature of the King's Head further changed as Llandudno developed. From being a local for miners it began to offer other, rather different, services. In the 1850s it became a venue for the sale and auction of buildings newly erected in the growing town. The landlord in 1857, John Jones, was the caretaker of the market hall for many years; he was also the town crier.

Towards the end of the century change was again in the air. In November 1889 the King's Head was one of over thirty places in the town to be up for sale, and in 1897 the pub was among those of the 'highest grade' in the district bought by Ind Coope & Co. Ltd. The brewery immediately set about enlarging and renovating their new purchases. The tourist trade though did not waver and by 1902 the tram service to the summit of the Great Orme was in operation – with the lower station sited in front of the King's Head. Since then the pub has served both locals and visitors alike.

25. The Snowdon Hotel, Tudno Street, Llandudno

After the Mostyn family had acquired the majority of Llandudno's allotments, the question remained what should be done with the land. After flirting with the idea of developing the shore area into a major harbour for crossings to Ireland, the natural beauty of the region persuaded them to develop a fashionable seaside resort instead.

Tudno Street, on the side of the Great Orme, was the first street built in the development of Llandudno around 1850; by the end of the decade, the railways had arrived in the town – the railway station and branch line opened in 1858 – and the street stood at its commercial centre. By 1860, No. 12 Tudno Street had been converted from a private house to a hotel, with William Davies as its first landlord. An advertisement for the hotel in a trade directory of 1886 states, 'Wines and spirits of the best quality. Families supplied with bottled ale and stout in prime condition. Apartments with or without board.' (One presumes the word 'families' was to distinguish the patrons from commercial travellers, rather than implying Mr Davies supplied alcohol to children). The house next door was purchased later and the two were combined to form the present building. The small public bar is sited in what was a lean-to, with the bay window at the end of the original building now incorporated into the bar's structure.

Although it no longer offers accommodation, the Snowdon is one of the few remaining traditional pubs in Llandudno. The 1970s saw its darts team as finalists in the *News of the World* darts competition; the pub also hosted the rather less traditional sport of piano-smashing during this decade. The Snowdon's latest addition of an attractive terrace at the front of the pub recently won it an award in the 'Llandudno in Bloom' competition.

Above: The Snowdon.

Below: The bar of The Snowdon.

26. The Marine Hotel, Vaughn Street, Llandudno

The history of the Marine Hotel closely mirrors that of Llandudno itself. In the late 1840s the site upon which the hotel would be built was little more than common pasture above the beach. By 1853 the plans for the new resort town were being turned into reality: in that year Lord Mostyn applied to Parliament for an Improvement Act which would set up a board of commissioners to oversee this transformation. Eleven years later Llandudno had three large and two small hotels, one of the larger being the Adelphi, the original name for the Marine. This was also the decade when Llandudno's dream was meeting a harsher reality and teething problems were intensifying.

At the Llandudno Improvement Commissioners' meeting just before Christmas 1864 a number of rather worrying reports were submitted. The issues included pigs in the town, which it was thought should be banished, the belief that the sewers should be flushed at least twice a week and that cesspools and privies should be rigorously prohibited; a number of houses and cottages had no drains at all. Furthermore, the tank outside the Adelphi was not in working order for flushing purposes, neither were the other two close by. The general air of Llandudno during the previous summer was likely to have been rather unattractive to visitors. Over a year later on and not much had changed. The waste ground beside the Adelphi was now a rubbish tip, the footpath did not reach the hotel, and the carriage road had a steep and dangerous drop on one side. Yet improvements were made and less than ten years later it became fashionable to plant trees in the town; Mr Hayne of the Adelphi planted one in Mostyn Crescent.

Llandudno continued to develop over the next couple of decades, quickly becoming a fashionable resort that attracted distinguished visitors, many of whom stayed at the Adelphi. In August 1888 His Eminence Cardinal Manning and his secretary stayed at the hotel and expressed his delight with what he had found. In the previous September the bay had been enlivened by a steam yacht bearing the Marquis of Anglesey, who was welcomed ashore by Mr Eberle of the Adelphi and taken there for luncheon. Mr Eberle later took his lordship on a tour of the hotel which had been recently refurbished and decorated. As he left to return to his yacht the Marquis expressed much pleasure with his visit, and intimated his intention of making the Adelphi the headquarters for the Liverpool Brigade of the Royal Navy Artillery Volunteers, of which he was commander.

The most famous of Llandudno's guests during this period was Pauline Elisabeth Ottilie Luise zu Wied, born in 1843 in Wied, a small principality on the banks of the Rhine. She was a prospective bride for Britain's future king, Edward VII, but in 1861 she met Prince Charles of Hohenzollern in Berlin, whom she married. In 1866 he became Romania's head of state; they became King and Queen of Romania in 1881. Queen Elisabeth devoted herself to charitable works in her new country and began writing prose, poetry and plays under her nom de plume of Carmen Sylva. One of her better-known works is the rather gruesome *Steria's Revenge*, published in 1889.

Unfortunately for her she encouraged the romance between one of her ladies-in-waiting and the king's nephew, heir to the Romanian throne. This affair resulted in her exile, during which she spent five weeks at the Marine Hotel over September and early October 1890. Although initially disliking the place she appears

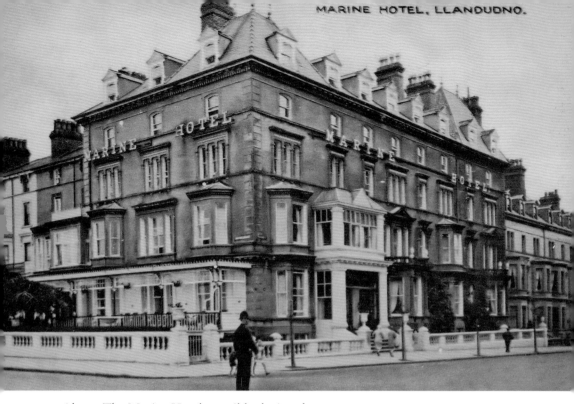

Above: The Marine Hotel, possibly during the 1930s.

Below: The Marine Hotel today.

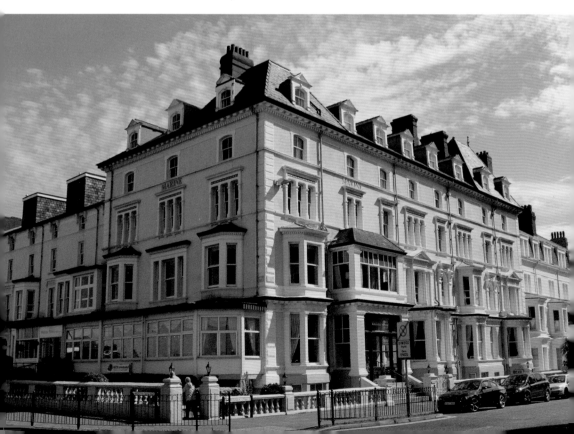

to have been quickly won over to its charms; she made many contributions to the town, such as the £10 she gave in support of Llandudno lifeboat station.

In later years she promoted higher education for women, placed herself at the head of a campaign for the abolition of corsets in 1909, and perhaps most surprisingly, wrote in her diary that she considered a republican form of government preferable to monarchy.

After she had left Llandudno the *North Wales Chronicle* noted how the town had benefitted from her presence, as it had 'never had such a cheap and broadcast advertisement' as that arising from her visit. If it had not been before, Llandudno was now certainly on the map. What was also on the map was the change of name from the Adelphi Hotel to the Marine Hotel by 1890.

Thirty years later, on 9 October 1920, the Marine Hotel was the scene of Llandudno's worst ever hotel fire. After the damage had been repaired the hotel continued in business up to the Second World War, when it was taken over by the government as a tax office. On returning to its function as a hotel it was enlarged in the 1960s by the purchase of neighbouring Kenilworth Hotel, then in 1996 with the purchase of Regent Court Hotel. Restructuring and renovation work was carried out to create the present 115-bedroom hotel.

27. The Palladium, Gloddaeth Street, Llandudno

The Palladium Theatre was built on the site of Llandudno's first market hall, which was opened by the Llandudno Market Company in 1864. The market hall was much larger than the theatre that replaced it, extending behind the current building and occupying part of what is now the car park behind the town hall.

An article in the local press in early 1919 announced that several prominent local tradesmen had joined forces to buy the leasehold of the property, with the intention of erecting a large 'high-class music hall and picture theatre as soon as conditions permit'. The new building had an imposing Edwardian baroque façade flanked by giant square towers, each capped with an octagonal dome that sported a seabird on its highest point. The main entrance had a pediment, pilasters and four shops with curved glass windows. The interior was no less opulent, if a slight mish-mash of periods and styles: the 25-foot circular entrance foyer had a Georgian-style domed ceiling supported by classical pillars, and the interior decoration of the auditorium was reportedly 'in the French style'.

Seating inside the auditorium provided a capacity of over 1,300 and was on three levels, with four boxes on each side of the stage and another three boxes behind the dress circle. Eight dressing rooms, a 'crush room' and open lounge – boasting extraction fans which changed the air 'four or five times an hour' – tip-up seats and sumptuous soft furnishings confirmed the Palladium as 'the most luxuriously appointed house in North Wales'. Various musical comedies and variety acts were booked for the opening season and a conductor from a famous London theatre engaged to direct the Palladium's own orchestra. The theatre opened its doors for the first time on Bank Holiday Monday, 30 August 1920.

It continued to offer a varied programme of drama, musical comedy, variety and ballet throughout the next three decades. The summer seasons during the 1950s and 1960s saw repertory stage productions and revues, with bingo being introduced on

GLODDAETH STREET, LLANDUDNO. W.586.

The Palladium when a theatre, 1920s.

some weekday evenings. The building was split in 1972 when it was taken over by the Hutchinson Leisure Group; the former stalls became a bingo hall, with a 600 seater cinema above in the former circles. It was subsequently taken over by Apollo Leisure, and closed down in September 1999.

The pub chain J. D. Wetherspoon bought the building shortly afterwards, and set about a major renovation. One of the conditions of the planning permission was that the interior should be restored as far as possible to its original condition. The bingo hall and cinema were therefore converted back to a single space and many of the theatre's original features were restored, including the boxes which now contain über life-sized photographs of appreciative Edwardian theatregoers in period evening dress.

The building was reopened as The Palladium in August 2001. The exterior was extensively restored in 2012/13, complete with seabirds atop the domes; this imposing building now looks very much as it would have done when it opened in 1920.

28. Cottage Loaf, Market Street, Llandudno

The Cottage Loaf is built on the site of a former bakery and warehouse, Dunphy's, which supplied the provisions for its five grocery stores around the region. It is generally thought that the warehouse's construction used beams and spars from shipwrecks, which at that time were common in the waters around Llandudno. The three-storey building was used to print local newspaper the *Llandudno Advertiser* between 1891 and 1912. It was demolished in 1980. Dunphy's continued as a family-run business until 1972.

On 4 November 1869 the Llandudno lifeboat *Sister's Memorial* (a rowing boat launched by horses) went to the aid of a vessel being driven ashore by a northwest gale and heavy seas. This vessel was the Dutch brigantine *Caterina*, en route from

Right: The Palladium today.

Below: The Palladium bar area, theatre balcony above.

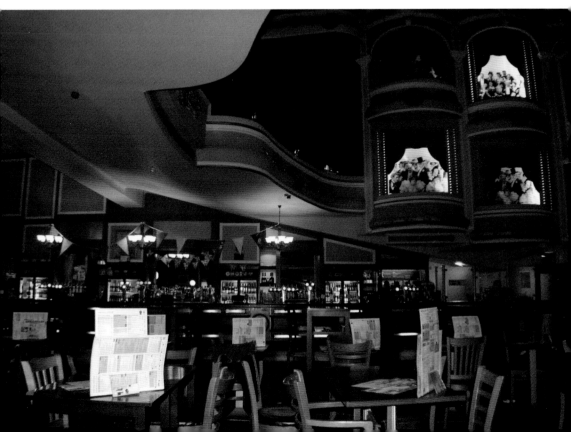

Runcorn to Riga with a cargo of salt; she ended up wrecked on the beach in the middle of Llandudno Bay, but the crew of five were saved by the lifeboat. The rescue was witnessed by Lady Augusta Mostyn, who was so impressed by the lifeboat crew's bravery that she later awarded each of them a golden half-sovereign.

Dunphy's bakery and warehouse was built shortly after this event, probably using timbers salvaged from the wrecked *Caterina* in its construction. After the bakery was demolished, these materials were utilised once again when building the Cottage Loaf. A mast, visible as you enter the building, still retains the copper strip which would have prevented the boom from wearing the mast down while it swung to and fro; while the ground-floor bar is made from two pieces of decking. Some of the structural beams may also have come from Llandudno's first pier, which was opened in 1858 but severely damaged in a storm the following year and eventually demolished to make way for the new pier in 1877. The stumps of the sixteen main supports are still visible under the present pier; their dimensions are an exact match for some of the Cottage Loaf's roof timbers.

Other recycled materials were also used: the wooden flooring in the pub's upper bar came from the former Lybro jeans factory in Liverpool, and the roof slates from the Royal Liverpool Hospital. The original cast iron oven doors from Dunphy's bakery have a more decorative function, set as they are into the front of the ground-floor bar.

The idea of having a pub on the site of the former bakery was the brainchild of local shopkeeper Bill Rowlands. Planning permission for the new pub appears to have been somewhat difficult to obtain. A 1980 report in the local press states that there had been objections from Llandudno's conservation area committee on the grounds that the pub's design looked 'too domestic' and 'not in keeping with the urban setting' – an objection which today leads one to wonder just what 'urban style' edifice would have met with approval. As it is, the building resembles the epitome of a traditional old country inn, both inside and out; so much so that the news that it was only constructed during the 1980s is often met with disbelief.

The Cottage Loaf, so named because of its link with the bakery previously on the site, was opened in September 1981. It has been the recipient of several CAMRA awards, as well as twice winner in its category of 'Llandudno in Bloom' in recognition of its attractive terrace and garden.

29. Craigside Inn, Llandudno

The original building on this site, on the coastal road from Colwyn Bay to Llandudno with the Little Orme immediately opposite, was a 10-acre farm set in fields in the township of Bodafon. Known as Shimdda (or Simdda) Hir – Welsh for 'long chimneys' – the farmhouse first appears in records in 1792. By the mid-nineteenth century the farm was tenanted out to Ann Jones by its owner William Griffiths, a solicitor from Llanrwst, and in 1843 Mrs Jones' elder daughter Mary took over the lease with her husband John Jones.

The house was subsequently purchased by Hugh Mullineux Walmsley, the second son of Sir Joshua Walmsley, a successful merchant and politician who was at one time Mayor of Liverpool. Hugh had a no less interesting, if not colourful, career: after

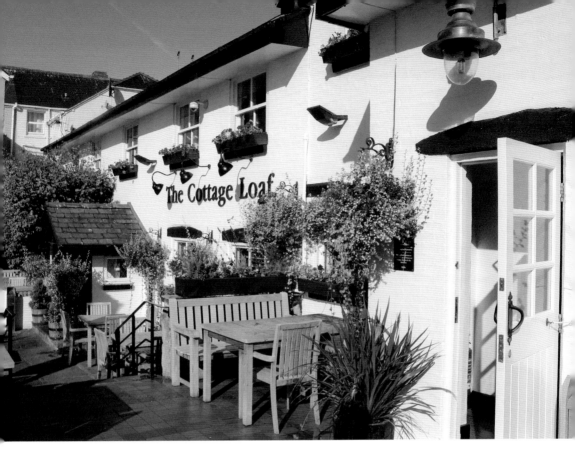

Above: The Cottage Loaf.

Below: The bar of The Cottage Loaf with old bread oven.

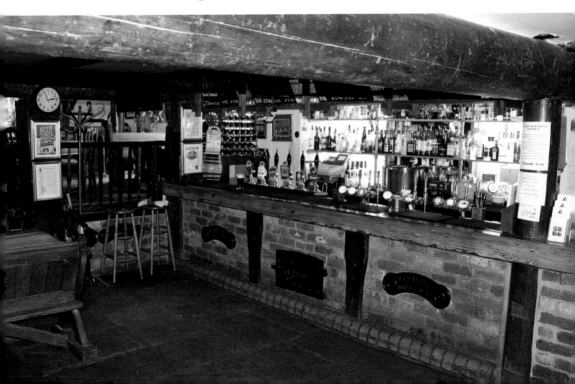

joining the army he spent some time with the 25th Bengal Native Infantry before volunteering with the Bashi Bazouks, essentially a band of mercenaries in the service of the Ottoman Empire, with whom he rose to the rank of Colonel. After returning to England he wrote a number of books, including memoirs of his own experiences in military service and a biography of his father. He also wrote some rather lurid adventure novels and, in 1864, a volume entitled *Llandudno As It Is* – suggesting that by this stage he had settled at Shimdda Hir. It is thought that he remodelled the farmhouse as a 'gentleman's residence' as befitted his status – although an unfortunate notice in the *London Gazette* in 1867 announced he was being sued for bad debt by a Llandudno draper.

After his death in 1879 the estate passed to the Holden family; in 1907, when rubble was being excavated for the construction of the new Mostyn Broadway in Llandudno, a wooden box was discovered containing more than 500 Roman coins dating from the late third century. The hoard was described in a contemporary archaeological report as having been discovered 'opposite to the stable entrance of Simdda Hir, on Mrs Holden's property'.

The estate was owned by the Holdens for several generations until 1970, when the main house and stable block were sold by Enid Margaret Holden to a religious order, the Sisters of St Mary of Namur. Miss Holden kept the two Shimdda Hir cottages, built in 1880 to house the coachman and gardener, and the nuns renamed the house St Mary's Convent. It was sold again in 1984 and turned into Craigside Manor (or *Le Manoir*), an upmarket hotel and restaurant; however, the success of this venture may be measured by the fact that just two years later the property was sold on yet again.

Craigside Inn.

It was bought by Whitbread PLC who named it Craigside Inn and converted it to a family-friendly pub and restaurant under their Brewers Fayre brand, with a Charlie Chalk Fun Factory on the first floor until around 1998. In 2009, Craigside Inn was extensively refurbished and extended, with a new adjoining Premier Inn increasing its overall size by almost double.

30. Penrhyn Old Hall, Penrhyn Bay

Although it survives today as a mostly Tudor manor house, parts of Penrhyn Old Hall date back even further. Some sources claim that the grandson of Cadwaladr, the last king of the Britons, built a palace on this site in the eighth century. The Penrhyn family are mentioned in records dating from the reign of Edward III (1327–77), and the building was described as an 'ancient stonehouse' in the 1549 itinerary of Henry VIII's antiquary, John Leyland. It was evidently an important place during the Elizabethan period: the cartographer Christopher Saxton included it in his mapping of the district in 1575, along with the area's four churches, but excluded two other manors known to have been in existence at the time.

Dating from the early sixteenth century, the south-west wing is the oldest Tudor section of the house. The baronial hall in this wing has an ancient carving above the fireplace with a symbol of Christianity, indicating that the elements of Eucharist were kept at the house. The room above the baronial hall is heavily beamed and trussed; an even earlier wattle-and-daub wall is decorated with sixteenth-century frescos, which had been covered over with whitewash and were discovered during renovations in 1910.

The north-east wing, originally a separate building, dates from the late sixteenth century when it was occupied by the Pughs, a powerful Roman Catholic family whose coat of arms is over the front doorway. In an age when Protestantism was the only religion allowed by the monarch and state these were dangerous times to be a Catholic, and the Pughs celebrated Mass secretly in the small chapel in the grounds. There is also a priest hole with room for six men inside the large fireplace in the current Tudor Bar, where priests could hide if the house was searched. After eventually falling into ruin the chapel was restored to use as a religious building during the twentieth century, but today lies derelict once more.

A stone dated 1590 above the fireplace commemorates Robert Pugh's domestic chaplain, William Davies. tipped-off in 1586 that local magistrates were on the verge of even greater persecution of recusants, Pugh and Davies fled to the Little Orme where they lived in the comparative safety of a cave for nearly a year. During this time they wrote a book together and managed to smuggle in a small printing press. The book was *Y Drych Gristianogawl* (The Christian Mirror), and is reputed to be the first book ever printed in Wales.

The men managed to escape in 1587 when their sanctuary was discovered, but were arrested five years later at Holyhead while trying to board a boat to Ireland. Robert Pugh again evaded capture, but Davies was incarcerated in the dungeons of Beaumaris Castle. He was convicted at Assizes of being a Catholic priest and hanged, drawn and quartered on 27 July 1593, after which parts of his body were displayed in the gory cautionary manner of the time on the castle gateways at Beaumaris, Caernarfon and Conwy. He was beatified by the Pope in 1987.

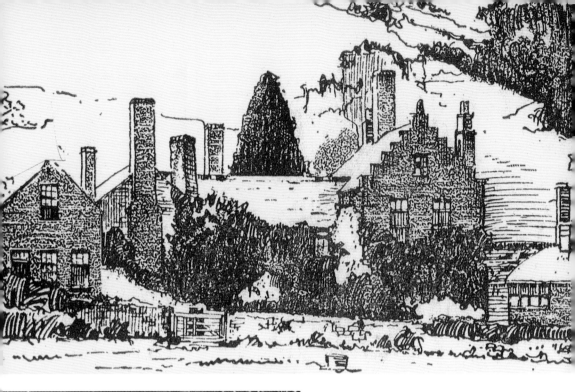

Above: Penrhyn Old Hall, 1909.

Left: Young lady spinning in the doorway, around 1920.

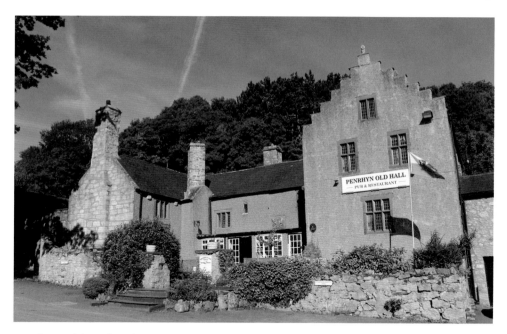

Penrhyn Old Hall today.

Penrhyn Hall became the home in 1760 of Dr John Williams, Archbishop of York and Lord Keeper of the Great Seal to James I. A Madonna cupboard dating from this period was used as the family's private altar and is today on display in the entrance hall. The house later passed to the Owen family, who found a hoard of Roman coins on the property in 1873; another hoard was discovered in 1907 by Edward Booth-Jones, an antiques dealer who occupied the house until he perished in 1915, along with his wife and two young children, in the tragic sinking by a German U-boat of the *Lusitania* as the family were returning from a business trip to America.

Following its use as a private house (and a farm during the latter half of the nineteenth century), Penrhyn became variously an antique shop and museum, a hotel, and tearooms. It was bought in 1963 by the Marsh family, by which time it was in a poor state of repair and required extensive renovation and restoration. It continues to be run by the Marshes today as Penrhyn Old Hall, a popular pub and restaurant which also offers varied entertainments such as skittles nights and paranormal evenings.

31. Old Station Hotel, Llandudno Junction

The small town of Llandudno Junction originally grew up around the railway station, which opened in 1858 as a branch line to Llandudno. A second branch line serving the Conwy Valley followed five years later, and in 1897 the London & North Western Railway opened its much larger new station slightly to the east of the original. The railway was once the leading employer in Llandudno Junction, and had its own locomotive and carriage sheds on the site which now houses a multi-screen cinema and various fast-food outlets.

A year after the new station, a hotel opened across the road: a handsome building constructed of red brick in mock-Tudor style. In 1889, the first ever edition of the *North Wales Weekly News* – running to a mere four pages – carried an advertisement for the hotel, boasting first-class accommodation for 'tourists and commercial gentlemen', and offering 'prompt attention'. In 1900, a stable block and grooms' accommodation was added.

The Old Station has long been known locally as 'The Killer'. One version of how it got its name is that train drivers would get drunk there before their shifts, thereby turning them into possible 'killers'. Another version suggests that railway employees or passengers would 'kill time' there while waiting to begin work, or before catching their train.

The partially Grade II-listed building was put up for sale in 2010, prompting an outcry among the town's residents who felt it was a local landmark and an asset to the community. A campaign was launched on Facebook to try and save it, and shortly afterwards the owners changed their minds and withdrew it from sale (although whether the Facebook campaign was influential in this decision is uncertain).

Having undergone a total refurbishment at the end of 2013, the Old Station now bears on its walls framed prints of vintage railway travel posters. Although the featured railway companies are long gone, the posters hark back to an era when travelling on holiday by steam train was an exotic treat. Four clocks behind the bar display the time in, respectively, Paris, New York, Sydney and – fittingly for a station hotel in Wales – Cardiff, ensuring that passengers can still 'kill time' there without fear of missing their train.

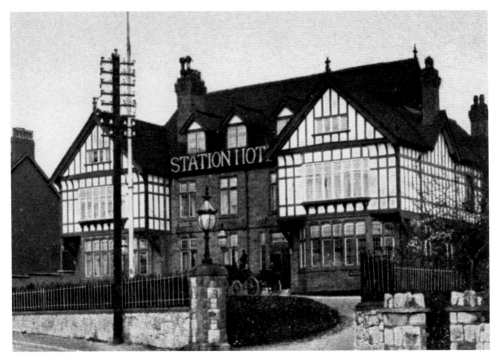

Station Hotel, early 1900s.

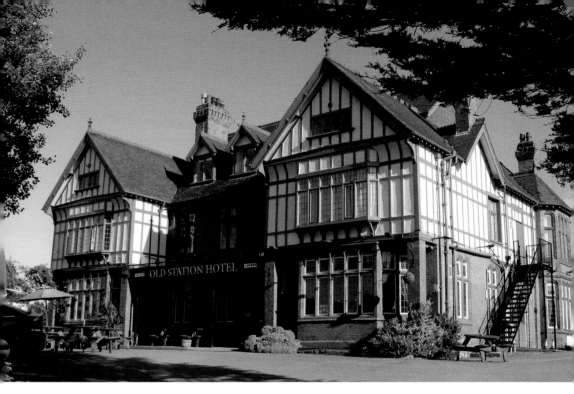

Above: The Old Station Hotel today.

Below: The bar of the Old Station Hotel.

West of Conwy

32. The Fairy Glen, Dwygyfylchi

The parish of Dwygyfylchi, west of Conwy, differs from others in the district in that it is bounded to north by the sea, to south by the mountains, and to the east and the west by two granite headlands which extend out into the sea, virtually isolating the parish. This topography made it a concern for travellers as it was on the mail and stage coach route from London to Holyhead. An eighteenth-century travellers' guide warns readers that they have to pass 'over a skirt of Penmaenbach' (the eastern headland) before they are obliged to go on to the sands. When they meet Penmaenmawr they have the option of continuing on the sands if the tide is out, otherwise they must follow 'a path difficult and dangerous' which is 'rough and steep with a perpendicular precipice on the right to the sea'. A later guide, published in 1767, maps this route exactly. In 1772 the new turnpike road was opened and became the route of choice at high tide. The road from Conwy now went over the Sychnant Pass behind Penmaenbach, and into Dwygyfylchi at the hamlet of Capelulo.

Nestled in a hollow at the end of the Sychnant Pass in Capelulo was the Cross Keys (its name before it became the Fairy Glen), which offered a welcome respite after the dangerous crossing of the pass. Horses could be watered and passengers refreshed, with accommodation available for those requiring it. The name Cross Keys was frequently associated with inns that had money-storing facilities, though there is no direct evidence that this was the case here.

Whatever the inn's services, its landlord had to be wary of opening at illegal times, even in quite remote areas. In July 1859, landlord Thomas Roberts was charged with doing just that. Five years later the licencing authorities granted his licence, so long as no complaint was made against him. He ran the inn quite successfully for a further ten years, but in October 1874 his widow and a Mrs Hudson put the establishment up for auction. The list for the inn makes interesting reading, for also included was a private house, stables, a cow room, public bakehouse and gardens. The auction blurb told prospective buyers that the inn was 'well-frequented' and that Dwygyfylchi 'lies in a sequestered spot surrounded by scenery of unsurpassed beauty'. The auctioneer

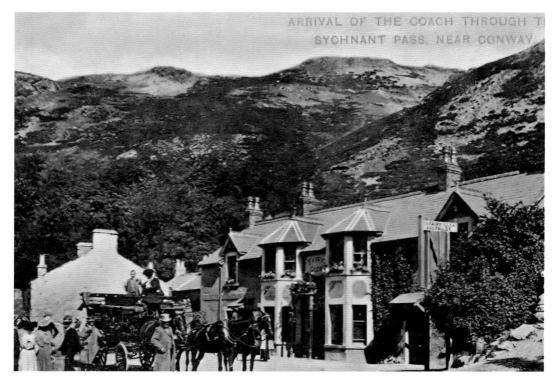

The Fairy Glen welcomes visitors in the early 1900s.

also believed that due to its closeness to Penmaenmawr, property in Capelulo was rapidly increasing in value.

The inn closed for a short period in the 1880s because Telford's coast road had taken away passing trade; the licence was transferred to the Ship at the west end of Penmaenmawr. Samuel Jones was, however, landlord in 1879 when he had to deal with a lost pony, and also in 1889 when he was summonsed for opening during illegal hours. Samuel died in 1891 and the licence passed to his widow. It was during the Jones' tenure that the inn's business picked up, offering refreshments to coach tourists on a circular route from Conwy, down the Sychnant Pass, returning to Conwy along the coast road.

In July 1896 the Glyn Estate was sold off. This estate comprised a number of properties and land in Dwygyfylchi, including the Cross Keys which sold for £800 to Messrs Marston & Sons, Brewers of Wolverhampton. Three months later plans were submitted for alterations to the inn, in particular for additional accommodation. Shortly after this the inn became the Fairy Glen, named after the popular walkers' destination of the nearby stream and hidden valley. It would not be long before a new form of transport, the car, would make the inn accessible for those wishing to enjoy the area's scenery of unsurpassed beauty, requiring refreshment as they did so. In 2001 the inn opened a new restaurant, built within the old beer cellar.

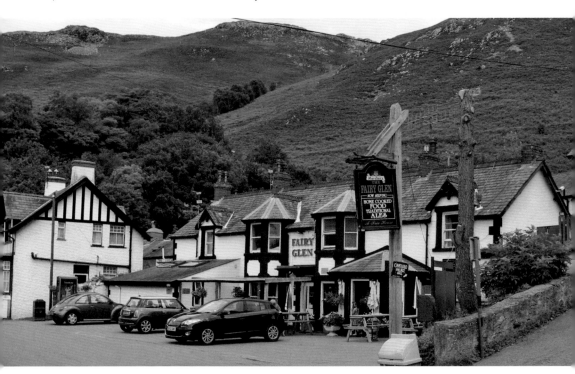

Above: The Fairy Glen today.

Below: The bar of the Fairy Glen.

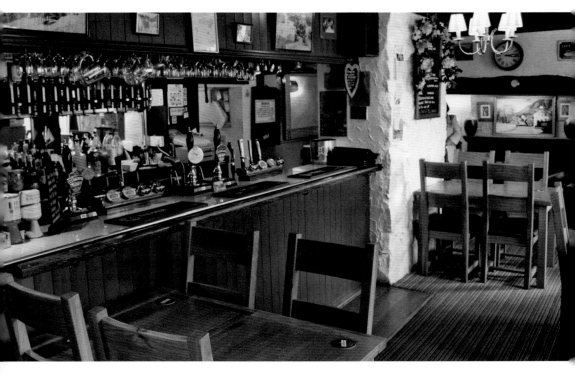

33. Former Mountain View Hotel, Bangor Road, Penmaenmawr

From Capelulo, the old road from Conwy dropped down into Penmaenmawr, a settlement that owed its original existence to the extensive quarries high above on the mountain top. The quarries began in the 1830s and the village gradually expanded into a fashionable resort over the course of the century. A writer in 1858 reported that while there were many houses to be let during the summer, and many snug lodgings, there was little accommodation of a public character. Only one hotel in Penmaenmawr is mentioned, the Victoria, which though small, was clean and comfortable. Penmaenmawr, though, was changing. Soon there would be the Grand Hotel (originally Penmaenmawr Hotel) close to the railway station, and from 1869, the Mountain View Hotel.

The Mountain View was built on the corner between the old Conwy road over the Sychnant Pass, and the new road above the shoreline. As these roads merge at an acute angle the hotel was triangular in shape, with the original door at the narrow angle. From the start it was both an inn and a pub, also catering for coach-borne tourists on the round trip from Conwy. The original trapdoor for unloading beer is still on the corner of the triangle; the cellar was previously a saw-pit used by the carpenter from across the road. The first proprietor is thought to have been Edward Pritchard, though by 1881 he had died and his widow Martha leased the hotel for 'a consideration' of £1,125. In 1893 Mrs Pritchard advertised for 'a good plain cook and to make herself generally useful'. She held the lease until 1896 when she returned to her home town of Liverpool and John Roberts took on the lease. Two years later, and the Mountain View was taken over by one of the big breweries, Samuel Allsopp and Sons Ltd, for the rather increased 'consideration' of £6,150.

Around 1900 an extension was built for a billiard room, which became very popular during the Second World War with the servicemen based at the nearby army camp. The landlord at this time was Ernest Edward Davies who had served during the First World War in the Royal Welch Fusiliers, where he met and served under Lord Mostyn. Mr Davies took on many responsibilities during his time at the Mountain View, including being Chair of the Penmaenmawr Council and President of Penmaenmawr Silver Band. He ran the hotel until about 1970.

The Mountain View has since ceased to trade as a hotel, and after lying empty for a number of years it is currently being refurbished for private use.

34. The Bron Eryri, Bangor Road, Penmaenmawr

The Bron Eryri was built in the early 1860s, though not as an inn. Many advertisements appear in the press during 1865 for William Robert of the Bron Eryri Post Office. He was also a newsagent selling *The Directory* and *The North Wales Chronicle*, and agent for the British National Life Assurance Association. However, even at the start of its career the Bron sold alcohol. Indeed the advertisements lead with a list of beverages on offer: ale and porter, bottled and draught, soda water, lemonade, ginger beer and cider. At a later date it may have operated as a café.

The Bron appears again by 1881 when the proprietor H. Davies was elected to the local board. By 1888 it was known as the Bron Eryri Vaults and its licensee

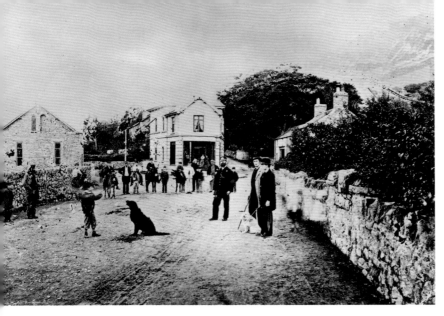

The Mountain
View Hotel,
around 1875.

Penmaenmawr
Hotel in the
1870s.

The Mountain
View today, no
longer a hotel,
undergoing
refurbishment.

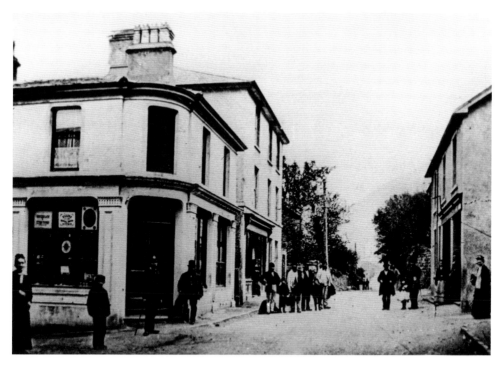

The Bron Eryri, around 1875, when it was probably a café.

was Thomas Williams. This was the period when property sales were held at the Bron. The start of the next century saw Penmaenmawr embracing new inventions. In 1900 it was reported that 'darkness prevailed' in Station Road West between Penmaenmawr Hotel and the Bron Eryri, a matter referred to the Roads Committee. Come 9 October 1903 and the council approved alterations to the hotel on the same day as the Roads and Improvements Committee discussed the proposed installation of electric light, an offer made by Lacey & Sillar of Manchester for twenty-five guineas (£26.25) inclusive.

By then the local milkman had run into trouble. Late in 1901 Elias Evans of Chapel Street was charged with leaving his horse and cart unattended opposite the hotel. PC Owens waited for fifteen minutes for the milk vendor to return. When he failed to do so the constable went in search of him and found him in the Bron. For leaving his horse and cart unattended while he went for a drink, the milkman was fined five shillings (25p) plus costs at Conwy Petty Sessions.

In 1917 the First World War was at its height. During the week ending 26 January, about ninety local quarrymen left for Wrexham and were drafted to the Quarry Battalion, training 'somewhere in England'. Before they left Penmaenmawr, some never to return, they were entertained to a supper at the Bron. Since this time the Bron has operated as a popular local inn in the centre of town. In the summer of 2015 it was refurbished and a beer garden was created.

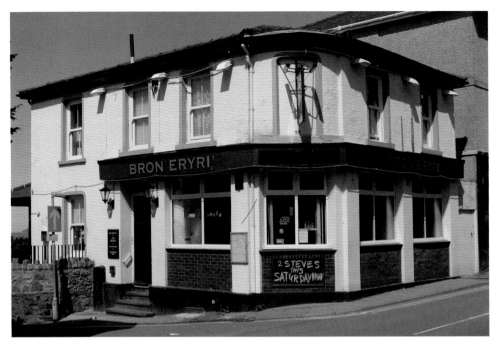

The Bron Eryri today.

35. The Gladstone, Ysguborwen Road, Dwygyfylchi

From the beginning of the eighteenth century when the parish of Dwygyfylchi was almost isolated, transport links gradually improved; the turnpike came across the Sychnant Pass in 1772, and Telford's new road, cut into the cliffs by hand and hugging the contours around the steep headlands, followed the coast by 1830. In 1849 the railway station opened and Penmaenmawr and environs were now easily accessible. From this period, the origins of Penmaenmawr as a coastal resort can be traced. Tunnels were built through the headlands in 1932 and 1935, making the parish now far more accessible by road. The early 1990s saw the completion of the expressway along this route, the A55.

Throughout all this the parish has altered, and accommodated the changes. The Gladstone is the latest manifestation of this. Originally a private house named Plas Arfon, in the 1960s it was converted into a pub called The Legend.

It was taken over by a family business in the early 2000s and renamed after Penmaenmawr's most well-known visitor, W. E. Gladstone, who served four terms as Prime Minister between 1868 and 1894. He holidayed in Penmaenmawr several times from 1855, staying with family friends and writing about the area in glowing terms in his diaries. The Gladstone has been refurbished in recent times, and in addition to the welcoming bar, it offers a restaurant, accommodation, and splendid views from the beer garden of Anglesey, Puffin Island and the Great Orme. The building stands prominently above the A55, all a far cry from the days when the parish was isolated from the world at large and reachable only by intrepid travellers.

Above: The Gladstone.

Below: The bar of The Gladstone.

South of the Coast

36. The White Lion, Llanelian-yn-Rhos

In the twelfth century, the small hamlet now known as Llanelian-yn-Rhos was called Bodlenyn. It was first referred to as Llanelian in 1599; at the end of the following century the antiquarian Edward Lhuyd wrote that it comprised five or six houses. In common with many of the country pubs in this volume, there is a close connection between the village inn and nearby church. In this case the church is St Elian's, and it is extremely nearby in the case of the White Lion, as one walks past its front door in order to access the church's main entrance. The pub's own website tells us that the first mention of a hostelry on this site dates from AD 722, when it is suggested that the church's elders collected their free monthly ale from the alehouse next door. It is

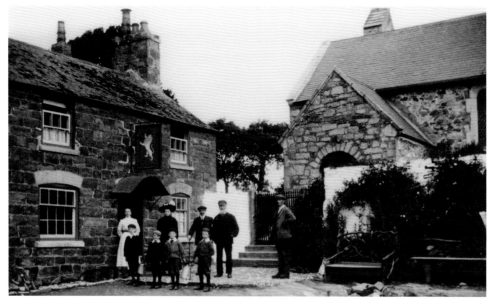

The White Lion, early 1900s.

possible that this was originally a rough wooden construction to house the builders of the original church, possibly in the sixth century. The oldest parts of the current church date from the thirteenth century.

Ffynon Elian (Elian's Well), located in a field close to the church and the pub, is one of a number of holy wells in the area. Pilgrims have been coming to such wells for centuries to ask for healing and wisdom, and in the case of Ffynon Elian, justice: by the late eighteenth century it was known somewhat ominously as a 'cursing well'. The guardian of the well would carve the petitioner's initials on a piece of slate, place it in the well and perform certain (not very holy) rites, for which service they would receive payment. The pilgrim would then go to the church to ask St Elian's blessing on their petitions and afterwards visit the inn for refreshment. The well's guardians appear to have made rather a lot of money from this enterprise; however, the guardianship ended in 1850 when the last guardian became a Baptist and nobody succeeded him.

The current pub has late seventeenth-century origins, although portions of it date back to the late fourteenth or early fifteenth century. Part of it was once used as a shippon (cattle barn) and granary, and there is a window in the wall overlooking the churchyard where beer would have been served in the days when the church grounds were used as a marketplace, or for other leisure activities. The White Lion's name comes from the coat of arms – displayed on the pub's sign above the door – of the Hollands, a significant landowning family from the area. In 1579 Humphrey Holland married Annest, the heiress of nearby Teyrdan Hall; there is a memorial to him in the churchyard dated 1612. Various Hollands were High Sheriffs of Denbighshire in the seventeenth and eighteenth centuries.

In 1902 an article appeared in the *Weekly News and Visitors' Chronicle* under the titillating heading 'Excitement at the Village Inn'. It concerns a case heard at the Colwyn Bay Petty Sessions where the licensee, Margaret Parry, was charged with refusing to admit a police sergeant into a room of her premises. One Sunday morning the police sergeant saw three men leave by the inn's back door. He entered the building and asked Mrs Parry's daughter, Elizabeth, who the men were. She replied that they were the coachman of the Bishop of St Asaph – who was preaching at the church that morning – and two other coachmen from a nearby estate. The sergeant then noticed spilt beer on a table, which Elizabeth 'quickly wiped away'; he then made to enter a larder, which Elizabeth locked and refused to open for him, saying that her mother was in church and had left instructions that nobody was to go in that room in her absence. The sergeant then left the inn and returned twenty minutes later with the local constable. The larder was duly unlocked, and found to have nobody inside (although it was stated in evidence that it had a window to the kitchen through which beer was served). The defence lawyer stated that Mrs Parry had held the White Lion's licence 'with unblemished character' for over fifty years. Despite the sergeant's obvious suspicions that an illicit Sunday-morning beer drinker had legged it out through the pantry window, aided and abetted by Mrs Parry's daughter, the Bench did not endorse her licence. She was, however, fined £1 plus costs.

The *Welsh Coast Pioneer* carried a report in July 1904 'on good authority' that gold-mining operations had resumed in Llanelian following the discovery of gold ore in quartz from the well at the White Lion. The quartz was said to be 'very rich in gold'

and that 'important developments are expected'. Sadly, this appears to have been the first and last report on the matter.

A photograph currently on display in the White Lion's main bar shows a Mr Roberts seated inside the inn. It was run by his family for thirteen generations; his granddaughter was born at the inn, and still (at the time of writing) lives in the village, aged eighty-eight. It has been owned by the Cole family since 1989, and is currently run by the second generation of Coles.

The White Lion continues to enjoy a reputation for serving good food and fine ales, and has featured in the CAMRA Good Beer Guide for twenty years. It also offers regular entertainment such as Jazz Nights on Tuesdays and the intriguing Ukulele Sing-a-Long Sundays.

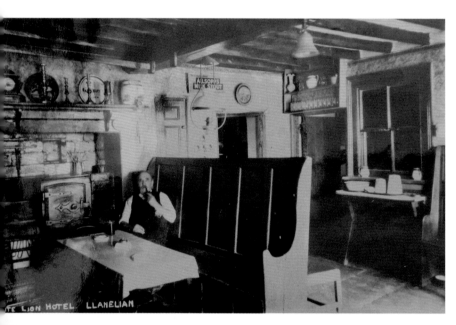

Mr Roberts, landlord of the White Lion, early 1900s.

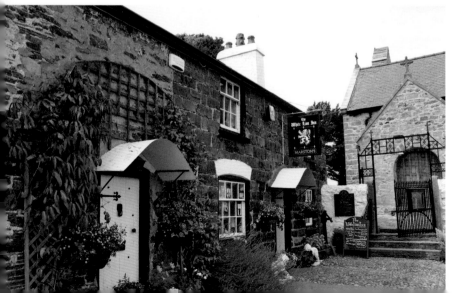

The White Lion today.

37. The Black Lion, Llanfairtalhaiarn

The pretty village of Llanfairtalhaiarn nestles in a valley of the River Elwy, along the Abergele to Llanrwst road. Although its early history is somewhat obscure, it may have begun as a monk's cell established by one Talhaiarn around the mid-sixth century, which over time evolved into a church consecrated to St Mary. This is suggested by the etymology of the village's name – the prefix 'Llanfair', widespread in Wales, roughly translates as 'church of Mary', with the suffix generally implying 'associated with'. The first use of the modern name comes in 1839. Little or nothing remains of the village's medieval origins, with most of the existing buildings and structures – including the narrow three-arched bridge, which still carries all traffic from the main road to the village – dating from the eighteenth century.

Llanfairtalhaiarn once had two pubs; the Old Harp Inn, now a private house known as Hafod-y-Gan, was distinguished as being the birthplace in 1810 of the architect and poet John Jones whose bardic name was Talhaiarn, after the village of his birth. In middle age Jones was horribly plagued with gout and in 1869, still living in the Harp, he shot himself in the temple with a pistol and died a week later from his injuries.

By 1898 the Black Lion was the only licensed premises in the village, although the license was withheld by magistrates that year at the annual licensees' meeting as two men were being charged with being drunk on the premises. The report goes on, 'I also wish to state that there are to this house three back entrances, which causes it to be most difficult of supervision' – a state of affairs which appears to have been rather common in those times.

In 1899 the inn was at the centre of a major traffic accident: a coach carrying twenty-six tourists took a wrong turning near the village and careered down a steep incline, completely turning over in the process. The passengers were thrown from the vehicle; many of them suffered serious injuries. One man broke a leg and an arm, another had all the tendons in his right leg broken, and there were many broken noses and severe cuts and bruises. A Mr Fletcher, who had been knocked unconscious in the accident and was bleeding from a bad head wound, was taken to the Black Lion along with his

The Black Lion, early 1900s.

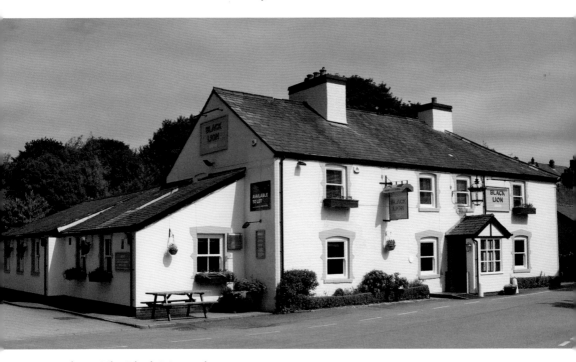

Above: The Black Lion today.

Below: The bar of the Black Lion.

wife, who fortunately had only suffered bruising. There they were tended to, while others were taken to the local doctor's house for attention. The coach was eventually righted by villagers and took the remaining less seriously injured passengers to Rhyl.

In March 1943 the Black Lion was put up for auction at the Bee Hotel in Abergele. The sales particulars describe the property as having facilities such as two smoke rooms, a 'Gents' Snug', a bar with six service windows, and two kitchens – one of them resplendent with a 'Gradient' Double Oven Range. It also offered no fewer than ten letting bedrooms. Outside buildings included a washroom 'with boiler and water laid on', a WC and urinal, stables, and a pig-sty. It was bought by Robinsons (the brewery founded in Stockport by Frederic Robinson in 1849) making it that brewery's first pub in Wales. A major refurbishment in 1982 included an extension, and central heating was installed for the first time to replace the previous open fires.

The close proximity of the village to the River Elwy means that it has been prone to flooding. The river breached its banks in 1964 and 1976, and in November 2012 major floods in the St Asaph area also affected Llanfairtalhaiarn; water submerged the Black Lion's carpark and rose to a depth of four feet. However, the village rallied around and a workforce of locals helped staff and workmen to ensure it was reopened in time for Christmas.

38. The Old Stag, Llangernyw

The Old Stag was built as a farmhouse in the mid-seventeenth century in a small settlement centred on the church of St Digain. Although the current church building dates from around the thirteenth century, historical evidence suggests there may have been a much earlier church on the site dedicated to the fifth-century saint; there are even hints that it was the *clas*, or mother church, for the area. Within the churchyard stands an ancient yew tree which is classed as one of the fifty Great British Trees by the Tree Council. The claims that it is 4,000 years old (or possibly older) are sadly unsubstantiated; whatever its true age, it remains one of the oldest living things in Wales, an undeniable attraction that draws many hundreds of visitors each year, many of whom seek refreshment at the Stag.

In 1890 a court application was made for a publican's licence, and the farmhouse became the Stag Hotel. Its name was derived from the coat of arms – still displayed on the outside front wall – of local landowners, the Lloyds. In 1927 the hotel had the distinction of being the only place between Abergele and Llanrwst where one could purchase petrol, which was pumped by hand; along with the facilities on offer inside, the Stag could thus be said to have been a prototype service station. Trade was doubtless further boosted around this time by the weekly markets in the hotel's yard.

The Woods family took over the Stag in 1963, the same year mains electricity finally reached Llangernyw. They ran the hotel for twenty years. During their time there, they updated it by installing central heating and fitted carpets. The Stag ceased trading as a hotel in the late 1980s but continued as a pub.

The impression as one enters the main bar is a slightly bonkers combination of old inn – with original tucked-away cubbyholes and interconnecting rooms – and eccentric antique shop. Artefacts and curios throng every surface, including the walls

Above: The Old Stag at dusk.

Below: The unusually decorated bar of The Old Stag.

and beams from which hang a miscellaneous collection of items such as a pair of skis, a stuffed alligator, ice-skates and an old camera, as well as china mugs, teapots and chamber-pots. This dates from a tradition whereby visitors could claim a free pint if they donated an item which could be hung from the ceiling. The Old Stag operates today as a popular pub and restaurant, with regular events such as Curry and Quiz nights, an Over-60s lunch club and a free meal on customers' birthdays – provided they take along supporting evidence.

39. Holland Arms, Trofarth

Y Dafarn Newydd (The New Tavern) was built in 1796 by John Morris on land owned by the Coed Coch estate, and its first licence was granted later that year. Map evidence suggests that it was built on a green-field site at the junction of three main roads linking Abergele (on the main coach and posting route), Llangernyw, and Eglwysbach. This was at a time when the population of Wales and England was beginning to grow rapidly, industrial activity was developing (though not, perhaps, in Trofarth itself), and turnpike roads were carrying an increasing tourist traffic. It was also the period when cattle were driven across country along drovers' roads to markets in England. In 1844 it was reported that Y Dafarn Newydd lay on the Public Road ('of breadth ten yards') towards the main road across North Wales, thus the tavern was, as it were, a local terminus. However, road users had to beware of reckless drivers; for example, David Davies, who was arrested in 1861 for riding past the tavern without reins in a wagon drawn by four horses. During the nineteenth century the customers would have been mainly local farmers and other agricultural workers, and occasional coach traffic.

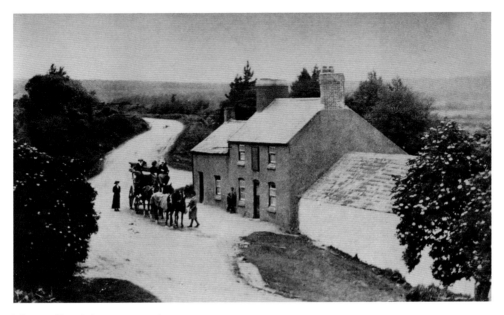

The Holland Arms around 1900

The original building was relatively small compared to today's structure. It was extended and modified a number of times around the late nineteenth and early twentieth centuries, though original features remain, such as a number of roof beams.

Evan and Jane Morris took over occupancy of the tavern around 1820. Their licence requirements in 1827 make much of what was not allowed: no diluting the beer; no gaming with cards, draughts, dice, or bagatelle; no bull-, bear-, or cock-fighting; no entertaining those of 'notoriously bad fame'; no allowing 'dissolute girls and boys to assemble'; and no drinking during the 'usual hours of Divine Service'. The fact that these activities were specifically forbidden suggests they were likely to have taken place had the restrictions not been issued.

Evan Morris lived at the tavern until his death, in 1883, aged ninety-three. His second wife, also named Jane, was twenty-five years younger than himself, though no children were born of either marriage. Evan supplemented his income by farming surrounding fields; his holdings in 1861 totalled forty-one acres, though by 1881 (when he was ninety-one) this was down to thirty acres. Thomas Clarke took over occupancy but did not apply for a licence, and the tavern became a farm for nearly twenty years. When he died in 1897 the *Denbighshire Free Press* reported that he left behind a widow and several young children, and that he had been highly respected and much esteemed locally. His obituary notes his address as 'Holland Arms, Dafarn Newydd'; it was from around this time that the English pub name began to take precedence. Photographs of Thomas and his wife Mary (died 1898) are on display today in the bar. He was interred in Trofarth churchyard with a headstone engraved in English – unexpectedly, given his reported address.

Y Dafarn Newydd reverted to being a traditional Welsh tavern under the possession of John Roberts, who sold off most of the associated farmland. However, strong rural links continued: the *North Wales Chronicle's* Hunting Appointments column advertised that on 1 April 1899 (Easter Saturday) the Flint and Denbigh Hounds would meet outside Y Dafarn Newydd. This practice continued for many decades. The pub had several functions over the years, including being a garage, a post office and a shop. In more recent times the Holland Arms has been home to the Speed Sheep Shearing Championships, held since 2013 on August Bank Holiday. Local produce and locally brewed ales are still served to customers, just as in its former days when the tavern's food and drink originated in nearby fields.

40. The Bee, Eglwysbach

Many small villages across the district were once home to several pubs and inns, though today often only one remains. The trade was hit especially hard from around 1890 and many licences were not renewed by the authorities, often because it was considered that one alcohol-serving establishment for every 200 residents or fewer was a chief cause of poverty and a drain on the parish's resources. Yet some inns did survive, and even prospered.

Eglwysbach was once home to the Bodnant Arms as well as its next-door neighbour, The Bee, but the former closed in 1915, leaving The Bee as the sole village pub. In the mid-nineteenth century both places were associated with the local wool trade; behind

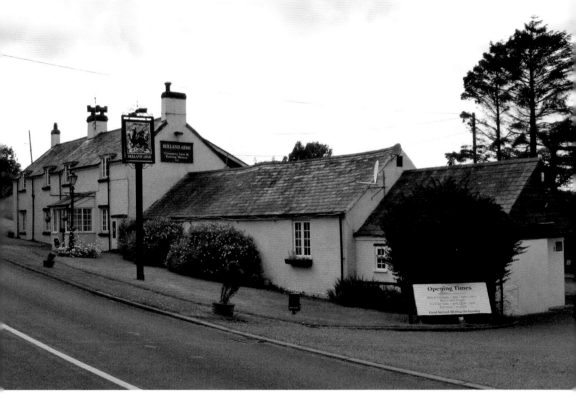

Above: The Holland Arms today.

Below: The bar of the Holland Arms.

The Bee there are still the remains of an oak house and stable blocks where fleeces were measured and sold. The pub building itself dates from around 1840 to 1850 and it once had a thatched roof; in earlier times it may have been the site of a farm.

For decades Eglwysbach had a defective water supply, especially in the summer months. The only source of water for villagers was one pump, and to worsen matters the village sewer lay in front of it with a slaughterhouse across the road. It was strongly suspected that this arrangement was a major reason for the continual occurrence of diseases such as scarlet fever and diphtheria in the community – and probably a motivation for drinking beer rather than water. The water supply was almost too inadequate to deal with fires; when one broke out in June 1900 in the hayloft above the Bodnant Arms (started by boys having a sly cigarette), it threatened not only the inn and an expensive horse in the stables below, but also the butcher's next door. Fortunately an impromptu fire brigade of villagers managed to tame the blaze with the help of the pump at The Bee.

Our photograph of The Bee, taken around 1900, shows its name to be the Pennant Arms. When John Lloyd ran the pub in 1872 it was called simply The Bee, and it is by this name that it appears in local English language news reports. It was also The Bee in 1910. However in 1904 there is a reference to it in *Gwalia* (a Welsh language newspaper) as 'Pennant Arms, neu y Bee' – 'Pennant Arms, or the Bee'. It is possible that it was known by a different name in each language community.

As was often the case in rural communities, the pub was the location for local business that fell outside of the church's remit, for example dealing with local rents. This function was evident in June 1900 when between thirty and forty tenants of Pennant Estate assembled for a dinner and the half-yearly rent audit. Pub landlords also often had an important role in the village: Hugh Holland Roberts, landlord of The Bee, was proposed as a Justice of the Peace for the county in 1898. His proposer was Robert Foulkes of Glan Farm, whose wife is standing at the doorway of the pub in the 1900 photograph. Soon after this the annual Eglwysbach ploughing match was initiated by Robert, now landlord of The Bee, on land owned by him about half a mile from the pub. We might surmise that much of the produce sold in the pub came from his land, or elsewhere in the village.

So it remains today. In March 2015 The Bee was named as the best place to eat in Wales in the pub category, winning the gold medal in the National Tourism Awards for Wales with a menu that features ingredients largely obtained from within the village, including nearby gardens.

41. Maenan Abbey, Maenan, near Llanrwst

Although not strictly speaking a pub – it describes itself as a country house hotel and restaurant – Maenan Abbey is still worthy of inclusion in this volume, mainly because of its close historical association with the town of Conwy.

In 1186 a group of Cistercian monks from Strata Florida Abbey established a community near Caernarfon, later moving further east where they founded Aberconwy Abbey in 1192. Following his defeat of Llywelyn ap Gruffydd in 1277, Edward I planned a chain of castles along the North Wales coast to establish and fortify his hold of the area. The first castle to be built, in 1283, was at Conwy; unfortunately for

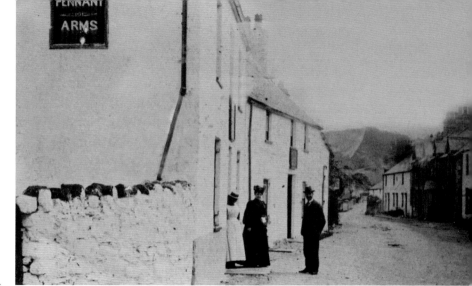

Mrs
Foulkes
in the
doorway
of The Bee,
early 1900s.

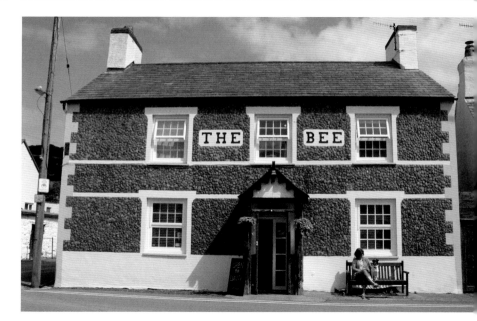

The Bee
today.

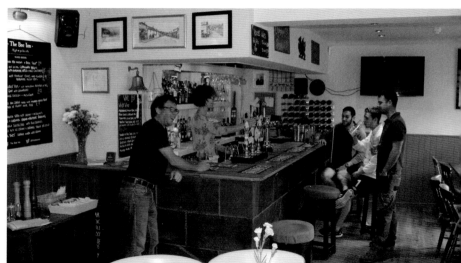

Conviviality
in the bar of
The Bee.

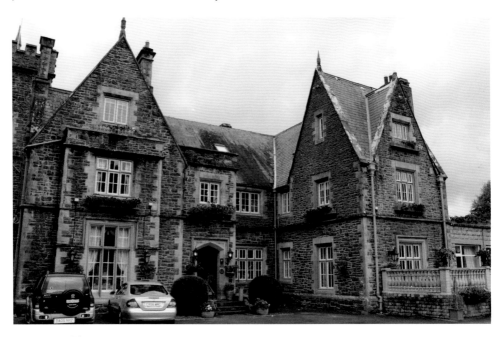

Maenan Abbey.

the monks, the spot he chose for his new castle and its surrounding walled town was where the monastery already stood. The monks were therefore moved down the valley to a new location at Maenan. They were given £40 as compensation for their lost land, as well as money and building materials to construct their new abbey. The monastery at Conwy was demolished to make way for the new castle and town, but the abbey church was rebuilt to become the new parish church of the fortified borough.

The new abbey at Maenan became extremely powerful; it was reputed at one time to own over 38,000 acres. There it remained peacefully, until 1537 when it became a victim of Henry VIII's dissolution of the monasteries and was torn down. Some of its stone was used to repair the castle walls at Caernarfon and the remaining materials, including lead, slates and glass, were sold to the landowners of the Conwy valley who used them to build their own manor houses. The land passed in 1599 to one of these landowning families, the Wynnes, who constructed a house approximately on the site of the current one.

The present house, of local granite and styled as a gentleman's residence, was built in the 1850s by the Elias family who lived there for much of the nineteenth century. A lengthy notice in the local press in 1914 advertised the house as coming up for sale at public auction in Llanrwst. The Abbey is described as 'an ideal and compact residential property. Excellent society. Capital homestead suitable for a gentleman's pleasure farm. Good mixed shooting and rights of fishery.' The advertisement goes on to describe the carriage drive and lodge approach, prolific orchards, productive kitchen gardens, numerous farm buildings, a bailiff's house and three smallholdings. As if this weren't enough for a gentleman who fancied playing at being a farmer, the Abbey also had a private railway siding and a small quay on the river.

At some point in more modern times the house was sold and turned into a hotel. In 2011, workmen carrying out drainage work in the hotel's grounds uncovered three medieval walls that were later confirmed as being part of the original Maenan Abbey. After the work was completed, they were covered over again and left preserved beneath the soil and turf.

42. The Groes Inn, Ty'n-y-Groes

The Groes Inn lies on the road to the west of the River Conwy which connects Conwy with Llanrwst. A couple of miles further south along this road stood the Roman fort of Canovium (Caerhûn) and, closer still, the alternative to the coast road across North Wales which crossed the river at Tal-y-Cafn. It is likely that most Roman traffic used the waterway as its link with the coast, though other travellers probably used a track following the course of the present B5106. Certainly by the seventeenth century this route was recognised as being a section of the horse post service from London, via Shrewsbury, to Holyhead. It was also the stage coach route, and Cary's *New Itinerary* of 1816 measures Llanrwst via 'Trefiew' to Ty'n-y-Groes quite accurately at seven miles. The Groes Inn was granted its first licence in 1573, but it is likely to have been a familiar stop along the road much earlier.

The Groes stands alone in a sparsely populated parish and would have functioned as more than a travellers' refreshment point; for example, for business and for bringing together landlords and tenants for the paying of rents. It was also likely to have been used to settle local disputes and would have functioned as a local court. In 1578 it was known as Taverne-y-Groes (The Cross Tavern) but at some later date its name was changed to the Commercial Inn, by which it was still known in the early twentieth century.

The earliest evidence for the building suggests a date in the 1700s. Whether this was the first to be built on the present site or whether an earlier structure lay at this location or nearby is not known. It was greatly altered and enlarged from the eighteenth century onwards. Plans are on record for alterations in 1903, and from 1939 for a petrol-filling station. More recently the hotel side of the business has been expanded to include fourteen en-suite bedrooms.

The oldest building was likely to have been between the two main chimney stacks. It was characteristic of a 'Snowdonia' type of house that is common in this part of Wales; with a main chimney heating the hall, a lesser chimney probably heating the upper floor, and a cross passage set off-centre leading to two rooms. A winding staircase leading to the upper storey was next to the large inglenook fireplace.

When the inn changed hands in 1889 one of the witnesses was the 4th Duke of Wellington, grandson of the bearer of the same name famous for the victory at Waterloo in 1815; these deeds are currently on show at the top of the stairs. To the right of the inglenook are original bread ovens, suggesting that travellers were offered freshly-made bread with their locally brewed beer. This tradition continues today as customers can sample Groes Ale, produced in partnership with the local Great Orme Brewery. In 2009 the Groes was named in *The Good Pub Guide* as Britain's 'Inn of the Year'.

The road from Conwy to Llanrwst takes the traveller between the mountains of Snowdonia on one side and the river and valley to the other. Though the journey today is likely to be far more comfortable than it was in the days of coaches, the Groes is still perfectly positioned to offer travellers a welcome drink, meal and accommodation.

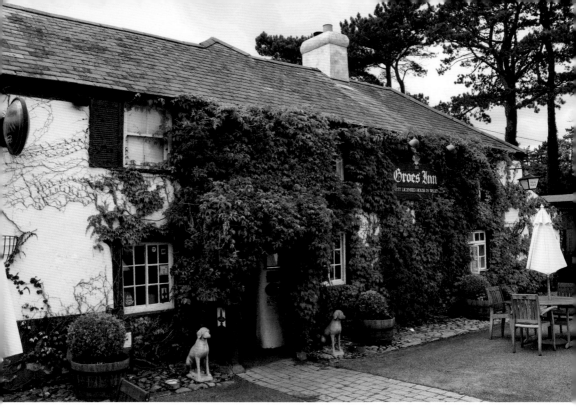

Above: The Groes.

Below: Entering The Groes.

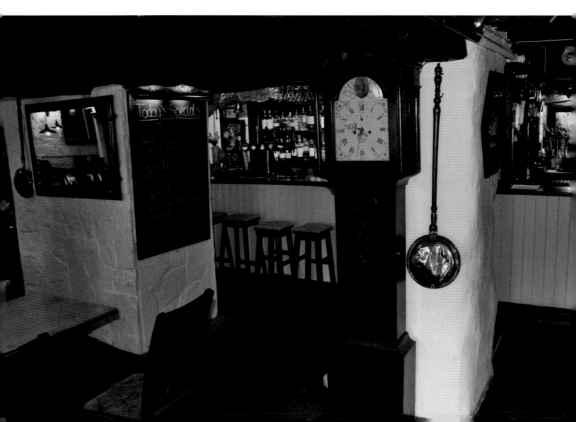

43. Olde Bull Inn, Llanbedr-y-Cenin

Lying at the heart of the small village of Llanbedr-y-Cenin, the Olde Bull Inn dates from the late seventeenth or early eighteenth century, although there may have been an even earlier inn on the same site. Like its neighbour the Ty Gwyn, the inn is next to an old drovers' road and would have served as a stopping-off point for farmers as they passed by with their livestock. Its name might have come from the bullocks which hauled carts along the mountain tracks that were too steep and rutted for horses.

The village takes its name from its church, St Peter's, which dates largely from the fourteenth century and is situated alongside the pub, as is common in this area. The Bull has the interesting characteristic of straddling the boundary of the Snowdonia National Park: its rear entrance stands within the Park, but exiting through the front door leaves it behind.

The inn has played a part in the establishment of the prestigious Royal Cambrian Academy of Art. In the latter half of the nineteenth century political unrest in Europe had made the traditional Grand Tour unwise, and a group of English artists, drawn by the wild beauty of North Wales and enabled by the spread of the railways to travel there with greater ease, had settled in the Conwy valley. In the 1881 census there were no fewer than eight artists enumerated in Trefriw. They established an 'Artists' Colony' in Tal-y-Bont and Llanbedr-y-Cenin, and for a time its members met in a room at the Bull. Membership grew to around forty and was instrumental in founding the Royal Cambrian Academy. Originally based in Llandudno Junction, it was constituted in 1886 and moved its operations to Plas Mawr in Conwy. Its president in 1934 was the celebrated Welsh artist Augustus John. In 1994 it moved to a purpose-built gallery a short distance away from Plas Mawr.

A less salubrious event at the Bull occurred in 1903 when the landlord, Joseph Jones, was charged with the unusual crime of harbouring policemen. A police superintendent had caught two of his fellow officers after closing time at the inn eating a bread and cheese supper and drinking beer. Mr Jones explained that the constables usually called earlier for their supper, but as it was Fair Day the pub was so full that he couldn't serve them any earlier. The judge dismissed the case, but the unfortunate police officers had their rank reduced by the Chief Constable.

In the early 1900s, sheepdog trials were held every New Year's Day in the fields behind the Bull Inn. These grew so popular, attracting competitors from as far afield as Cumbria and North Yorkshire, that in 1905 competition was restricted to North Wales. In more recent times, the current landlady Sian Watson has resurrected the old tradition of Boxing Day barrel-racing, where empty barrels are rolled up the steep hill through the village to the Bull at the top. Sian's two young daughters have the distinction of being the first two children born to the pub for around eighty years.

44. Ty Gwyn, Rowen

Popular today with walkers thanks to its location on the lower slopes of Tal-y-Fan within Snowdonia National Park, Rowen once boasted three mills as well as several inns and alehouses. The mills are now gone, and the Ty Gwyn is the lone surviving inn. Like its neighbour the Olde Bull, it is an old drovers' inn dating from the

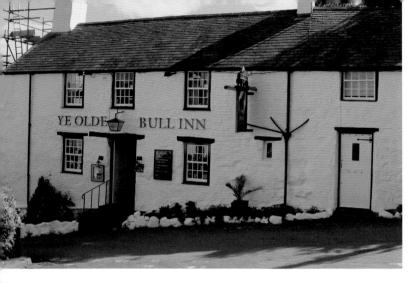

Ye Olde Bull.

Sian behind the bar at
Ye Olde Bull.

Ty Gwyn.

eighteenth or late seventeenth century. It is likely that the drovers' path followed the earlier route used by the Romans between their forts at Canovium and Segontium (Caerhûn and Caernarfon).

In common with many inns at the time, the Ty Gwyn was used in the nineteenth century for the annual collection of tithes (the ancient taxes due to the Church); in an area where worship at Nonconformist chapels was more common than in Anglican churches, this system was unpopular and even the cause of riots. On tithe collection day in January 1887 a group of resentful locals decided to demand a 20 per cent cut in their dues, and two men were dispatched to the Ty Gwyn to inform the Bishop's representative of this. They returned to tell the assembled company that the diocese would allow no more than a 10 per cent reduction; this pleased all but one man, a Mr Hughes, who left in a rage at his fellow tithe-payers having backed down from what had been agreed and saying that the diocese could sell his property before he would pay a penny more. A local newspaper called him 'the finest man in Caerhûn parish' for this act of defiance, although it is not reported what became of either Mr Hughes or his property.

An advertisement for the Ty Gwyn in the *Welsh Coast Pioneer* in 1905 states that a cab meets trains on request at Tal-y-Cafn Station, two miles away. It goes on, somewhat enigmatically, 'Good shooting, etc. An ideal spot for recuperating.'

Immediately next to the pub, a traditional red telephone box suggests that the Ty Gwyn might once have been used as the village post office. Its telephonic equipment having been removed, it now holds a surprisingly comprehensive selection of leaflets about local attractions, hiking routes and so on – making it perhaps the world's most compact tourist information centre.

The world's smallest information kiosk?

Acknowledgements

The authors would like to thank the following for their assistance in writing this book:

For help and general background information:
Conwy Archive Services; Chris Martin and the Clwyd and Powys Archaeological Trust; Angharad Stockwell and the Gwynedd Archaeological Trust.

For their time, knowledge of individual places, and the loan of and permission to reproduce personal photographs, pictures and other invaluable documents:
Simon and Nina Cole; Joe Egan and Will Lopez; Luke and Rod Faux; Geoff Hughes; Tracey Hughes; Guy Marsh; Dan McLennan; Paul Meredith; Daniel Packham; Stephen Reese; Darren Roberts; Dennis Roberts; Jane Selby; Robert Skelley; Sian Watson; Heron Webb; Marcus Williams.

And all other licensees, managers and bar staff who gave permission and assistance in taking photographs, and provided refreshment along the way.